Splash 2

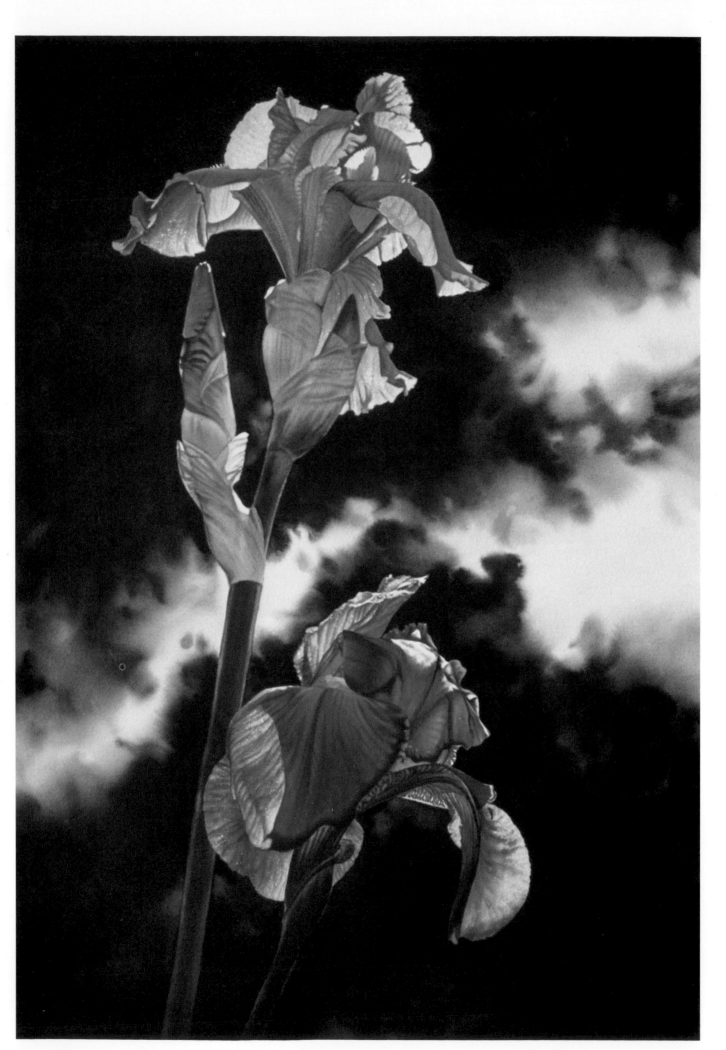

Iris #6, 42" x 29 ¹/₂", Linda L. Stevens

Splash 2

WATERCOLOR BREAKTHROUGHS

EDITED BY

Rachel Wolf

NORTH
LIGHT
BOOKS

CINCINNATI, OHIO

A B O U T T H E E D I T O R
Rachel Wolf studied painting and drawing at the Philadelphia College of Art (University of the Arts), and Kansas City Art Institute, and received her degree in fine arts from Temple University in Philadelphia. In addition to being editor for North Light Books, she continues to paint in watercolor and oil. She resides in Cincinnati, Ohio with her husband and three children.

Splash 2: Watercolor Breakthroughs. Copyright © 1993 by North Light Books. Printed and bound in Hong Kong. All rights reserved. No part of this book may be reproduced in any form or by any electronic or mechanical means including information storage and retrieval systems without permission in writing from the publisher, except by a reviewer, who may quote brief passages in a review. Published by North Light Books, an imprint of F&W Publications, Inc., 1507 Dana Avenue, Cincinnati, Ohio 45207; 1-800-289-0963. First edition.

97 96 95 94 93 5 4 3 2 1

Library of Congress Cataloging-in-Publication Data

Splash 2 : watercolor breakthroughs / edited by Rachel Wolf. — 1st ed.
 p. cm.
 Includes index.
 ISBN 0-89134-503-5
 1. Watercolor painting—Technique. 2. Watercolorists—Psychology. 3. Artists' materials. I. Wolf, Rachel. II. Title: Splash two.
ND2420.S65 1993
759.13'09'048—dc20 92-22244
 CIP

Designed by Sandy Conopeotis
End papers: *Phoenician Notation* (on its side), 38" x 32", Pat San Soucie

Pages 130-132 constitute an extension of this copyright page.

ACKNOWLEDGMENTS

A book like this is never the work of one individual. I would like to thank my editorial director, David Lewis, and senior editor, Greg Albert, who helped initiate this project and trusted me to carry it to completion. Thanks also to Greg for his help in selecting the art, as well as editing my writing and acting as general consultant.

I would like to thank editorial assistant, Lynn Haller, who efficiently helped me organize the mass of details that a project like this generates; as well as Terri Boemker for her help in guiding this book through production.

I would like to acknowledge Dale Laitenin, an artist whose work appears in *Splash 1*, who provided the idea for the three sections into which this book is divided.

Lastly, I would like to thank all of the wonderful watercolor artists who responded to our request for information about personal breakthroughs, both those whose work appears in this volume as well as those whose work unfortunately would not fit. Obviously, we couldn't have done it without you.

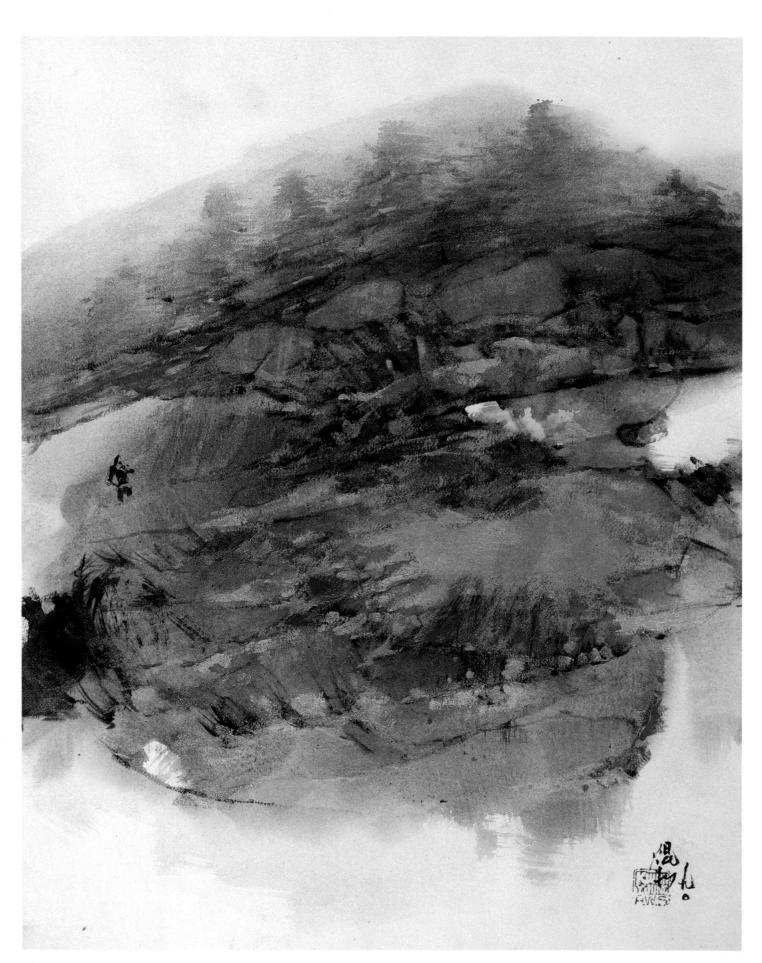

Shimmering Mountain, 26" x 20", Kwan Y. Jung

Contents

PART ONE

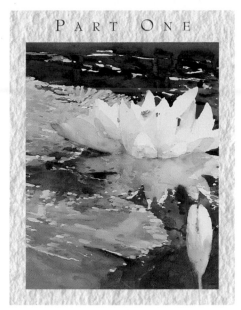

The Act of Painting

❧

The three chapters in this section spotlight breakthroughs that relate directly to the act of painting and show that a breakthrough can be right at your fingertips.

PART TWO

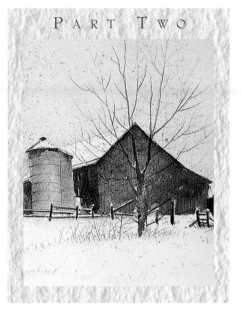

The Crossroads of Life

❧

Part two focuses on external life circumstances that were catalysts for artistic breakthroughs and prove that you can meet up with success in surprising places.

PART THREE

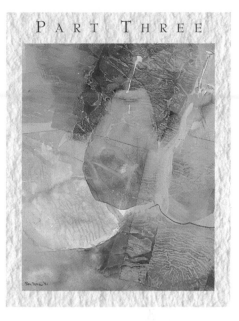

The Great Discovery

❧

This section celebrates the power of the inner spirit to effect change; you don't have to wait for a breakthrough — you can make it happen.

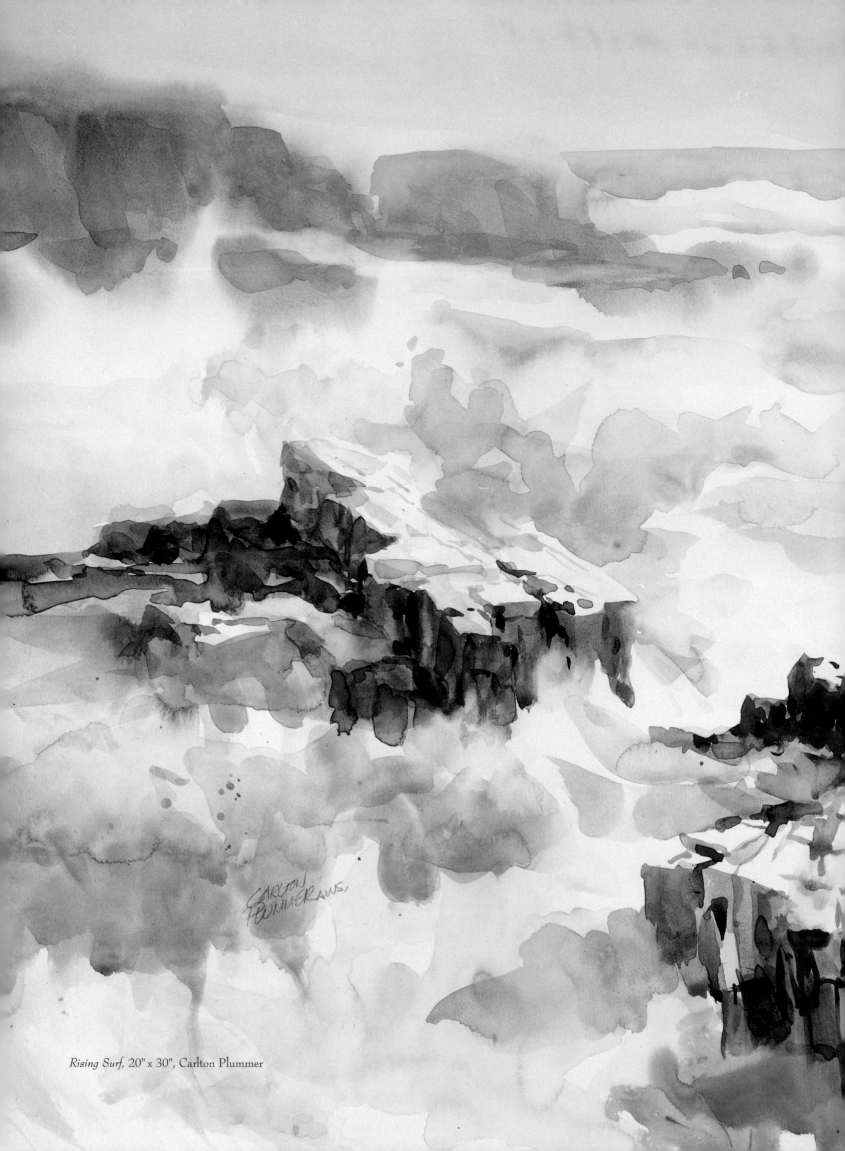

Rising Surf, 20" x 30", Carlton Plummer

BREAKTHROUGH:
An act or action of
breaking through
an obstruction, check,
or restriction to a radically
higher and broader
conception.

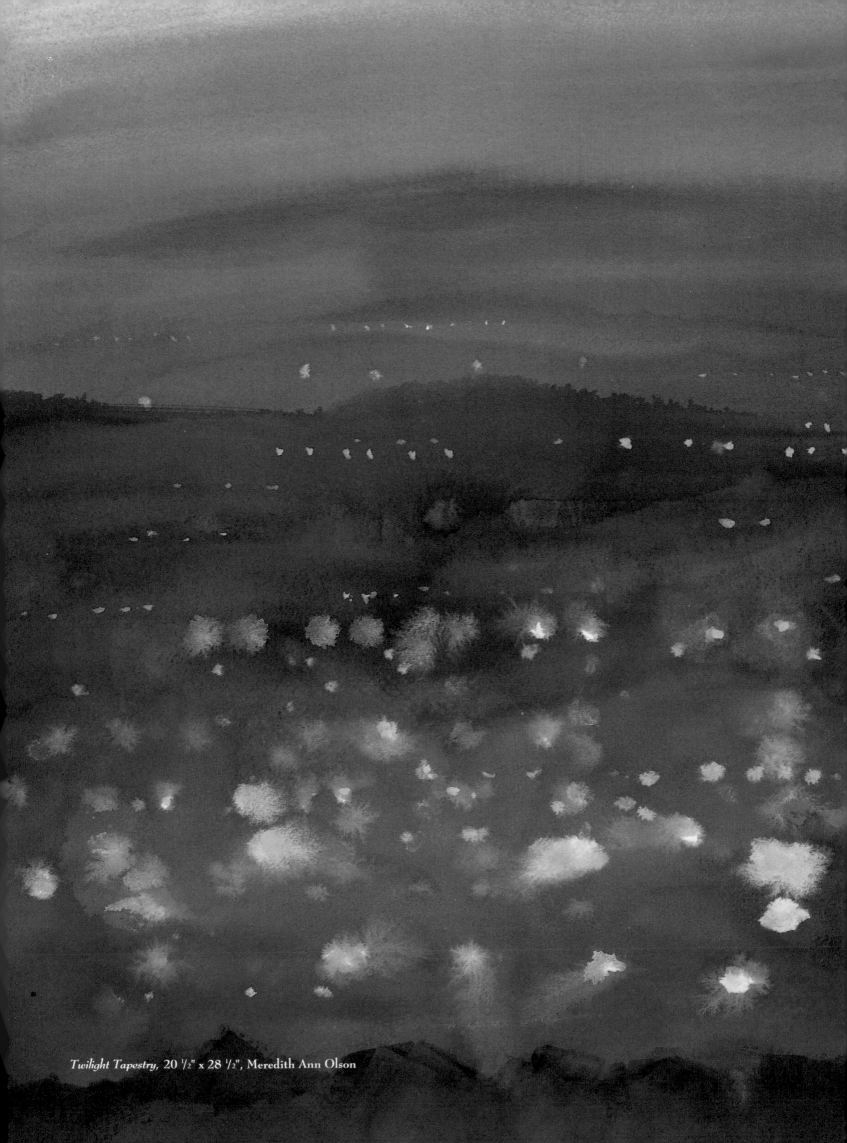

Twilight Tapestry, 20 ½" x 28 ½", Meredith Ann Olson

INTRODUCTION

Splash 1 is structured around the various elements that we as painters work with to produce a painting. It contains sections on technique, color, light, mood and creativity, to name a few.

As we searched for a theme for *Splash 2*, we asked ourselves, "Why do some watercolorists achieve a fair amount of success whereas others continue to be frustrated with their efforts? What has occurred in the lives and careers of these successful artists that has yet to happen for the rest of us?"

Then the answer hit us. Breakthroughs! Successful artists are able to create or maximize life experiences to break through artistic and personal barriers. We thought, "What if we cataloged a series of breakthroughs that a broad range of watercolor artists have experienced—and even showed the breakthrough painting where possible?"

The idea excited and challenged us. We didn't quite know what to expect in response to the queries we sent to watercolor painters all across America, but we were even more enthusiastic when accounts of personal breakthroughs started pouring in.

These accounts were wonderfully varied in nature and inspiring on many different levels. Our task then was to select and categorize both the paintings and the narratives. The breakthroughs fell into three main categories: the act of painting, the crossroads of life and the great discovery. But each story has its own unique perspective, born of real life experience.

We truly hope that the beautiful watercolors in this volume, as well as the descriptions of artistic breakthroughs told in the artists' own words, excite and challenge *you* to press forward in your own artistic ventures.

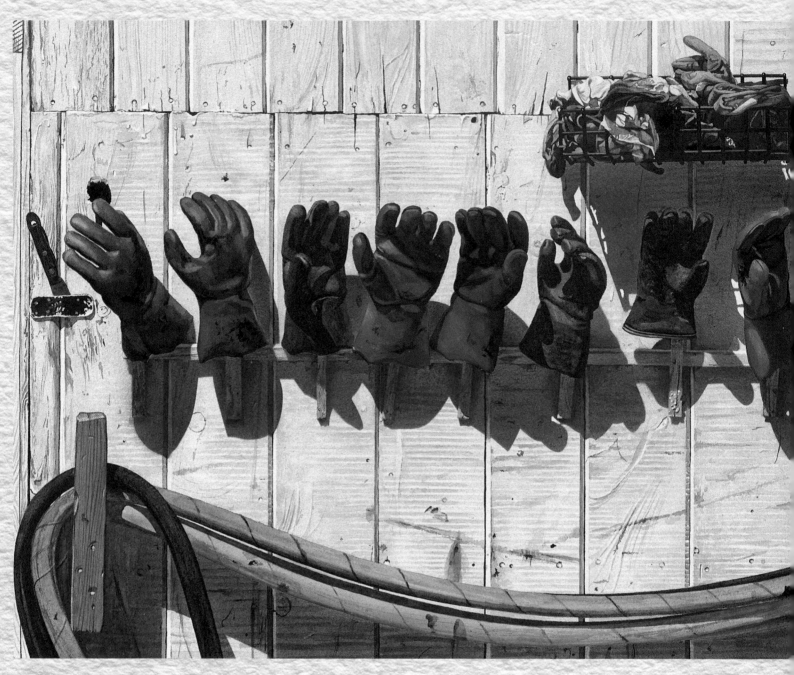

Bait Gloves, 17 ¾" x 34", John Atwater

JOHN ATWATER

The Act of Painting

Many artistic breakthroughs spring from the act of painting itself. The three chapters in this part spotlight breakthroughs that occurred in the studio or that otherwise related directly to the act of painting. These were sparked by the painting materials used, the technique employed, or by a new or adjusted painting process. In the first chapter you'll find artists who discovered vast new worlds by simply working on a new surface or using a different kind of brush. In chapter two, new avenues open up with stencils, various masking agents, VCRs, gouache and more. Chapter three tells us that breakthroughs can be found through purposeful struggling, by taking a break from your work, by traveling lighter, or even through daily sketching. In reading these accounts it becomes clear that a breakthrough can be literally right at your fingertips.

1
Materials

Don't get too comfortable with the use of your favorite colors, type of paper, or size of format if you want your work to grow.

—ELECTRA STAMELOS

Bridget
42" x 32"
Lynne Yancha

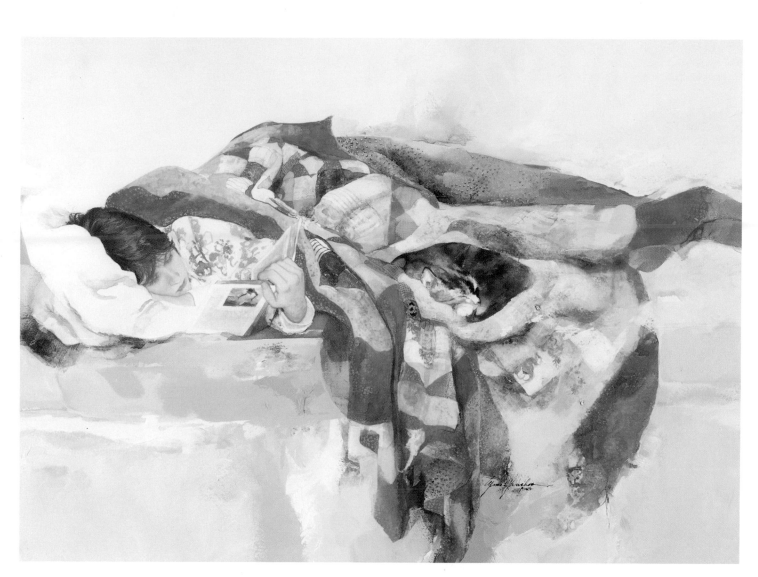

Home from School
39" x 42"
Lynne Yancha

Different Papers for Different Styles

Over twenty years I have watched myself travel through different stages of work; early on very abstract, moving slowly toward Realism. Several years ago I hit a peak of technical ability and by changing papers, my work diversified. I work in two distinct ways now and am having a lot of fun with both. My more detailed work, where I layer my color and push the watercolor to its absolute maximum, is done on 300-lb. Arches (cold-press), which takes a lot of abuse. *Bridget* is an example of this technique.

Home from School shows my freer work on 260-lb. Arches hot-press paper. Since I do a very detailed, polished drawing first, it was a delight to discover hot-pressed paper—the pencil caresses the paper; the detail is amazing. It becomes almost a meditation. The paper is not very forgiving, so I lay my color down carefully and delicately. It forces me to be patient. The paper dictated that I work in brief thoughts or vignettes, quite the opposite from my other work—full detail from corner to corner.

A lot is left to the imagination in these paintings, and the change is so refreshing for me.

Lynne Yancha AWS.

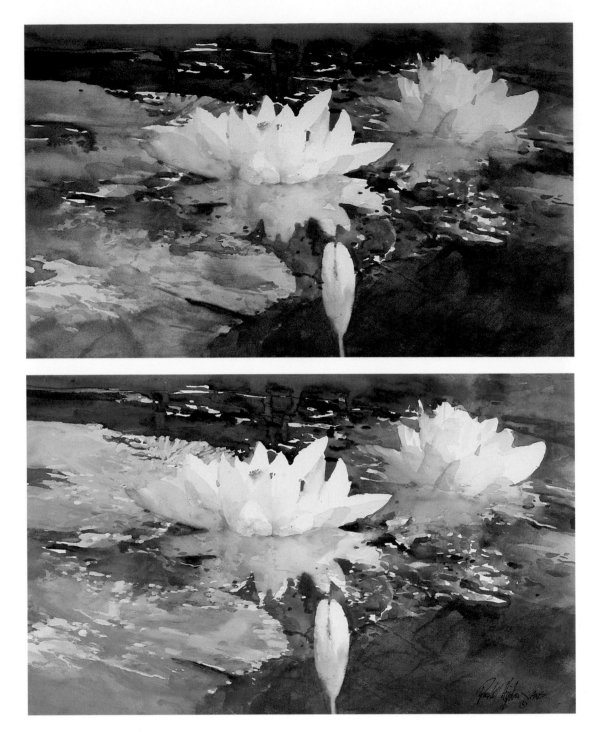

Reaching for Sunlight
14" x 23"
Randall R. Higdon

White Gouache for Final Adjustments

As one who enjoys the immediacy and beauty of transparent watercolor, I desire to achieve as much in one stroke of the brush as possible and in the least amount of time. Inevitably I often needed to "tidy up" edges or areas in the final execution. I also found myself wanting the option to expand or improve on composition and balance during the painting process.

To solve my dilemma, I started using white gouache or casein mixed with watercolor to make adjustments in the final stages if needed; be it detail or altering a shape or area. Over the years this has led me to use the white casein mixed with watercolor within a piece throughout all stages of execution if desired. A transparent watercolor underpainting is always present. Therefore, I am incorporating both transparent and opaque qualities within a single painting.

Above is the transparent watercolor version of *Reaching for Sunlight* prior to minor adjustments with watercolor/casein. Below it is the completed painting with casein/watercolor addition.

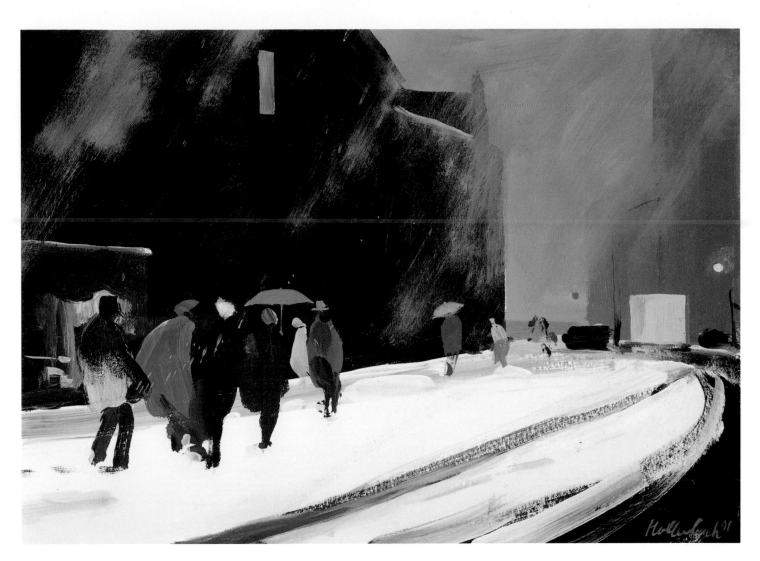

After the Snowfall
10 ¹/₂" x 14 ¹/₂"
Serge Hollerbach

Acrylics for Making Major Changes

All my paintings are impressions of scenes I have observed and landscapes I have seen. For instance, *After the Snowfall* was painted a day after I had memorized the scene. It took me several hours to do it—with minimal changes. The mental picture was there from the beginning.

Larger figure compositions take more time—several days or weeks. I add and eliminate figures, move them around, change colors. Only in acrylics can these major changes be done immediately without messing up colors. For me, transparent watercolors prohibited major changes altogether. This is why acrylic is my favorite medium and mastering it became a breakthrough in my career as an artist.

I paint on good quality, acid-free illustration board (paper mounted on board). It seems to me to be the ideal surface for acrylic painting, enabling me to use washes, glazes, textural application of paint, dry brush—you name it.

As for my style, I like to quote the late American painter Raphael Soyer, whom I had the privilege to know personally. When asked to describe himself as a painter, Soyer replied, "I am a frustrated Expressionist." And so am I. But a degree of frustration is good for us, psychologists tell us. It keeps our adrenaline flowing. It helps me, or so I hope.

Serge Hollerbach

The Cement Mixer
22 ¹/₄" x 29 ³/₄"
Neil Drevitson

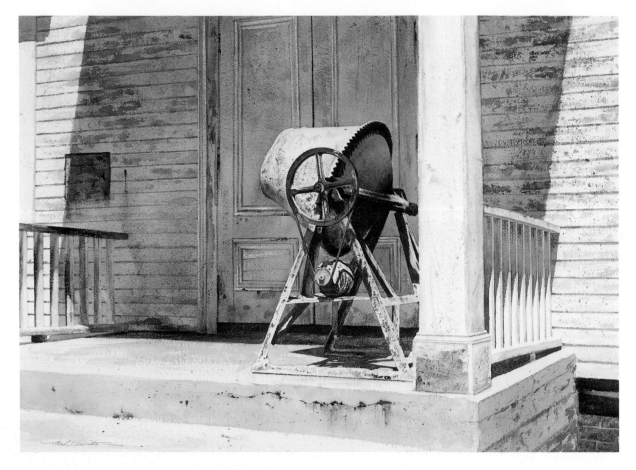

Challenge Yourself With a New Medium

Mention watercolor painting to anyone familiar with this medium and that person will quickly agree it is quite unique. No other medium can frustrate and challenge the artist, no matter how experienced, as can watercolors. Yet the inherent charm of a well-executed watercolor can inspire us and compel us to keep trying to master this most difficult of all mediums.

After achieving considerable skill through a good amount of experience with watercolors, I settled into a rather comfortable and (I felt) well-deserved reputation as an accomplished watercolorist. My watercolors were eagerly sought by collectors and galleries. I could barely keep up with the demand. But then I began to see a lack of color in my work that caused me to reassess the techniques I had used for years. I then decided to challenge myself with a new medium—pastels. Here was a medium of "pure color" …and no mixing! Just reach for the color you want, and scrub it on… lots of it. What fun! What freedom! What colors!

However, I really missed working in watercolors. And so, combining my experience in pastels with my newfound freedom and knowledge of watercolors, I started to have some really great fun with watercolors again. What a breakthrough! Now, not only was I using more vibrant colors (I completely changed my palette) and painting on new whiter papers, I was experimenting with textures. I was even going to such extremes as working pastels into my watercolors to add more color intensity to my work.

In *The Cement Mixer*, the intense orange rust on the mixer was achieved by weaving the color on with a dry brush, then delicately adding just the right amount of pastel.

I realize that there will be those few "purists" out there who will frown upon combining anything with watercolors. So may I say in closing that if it is done thoughtfully, and in good taste, you may find that the above-mentioned combination does not detract from, and may in fact add to, the unique charm of watercolors. It worked for me! There is no reason it shouldn't work for you.

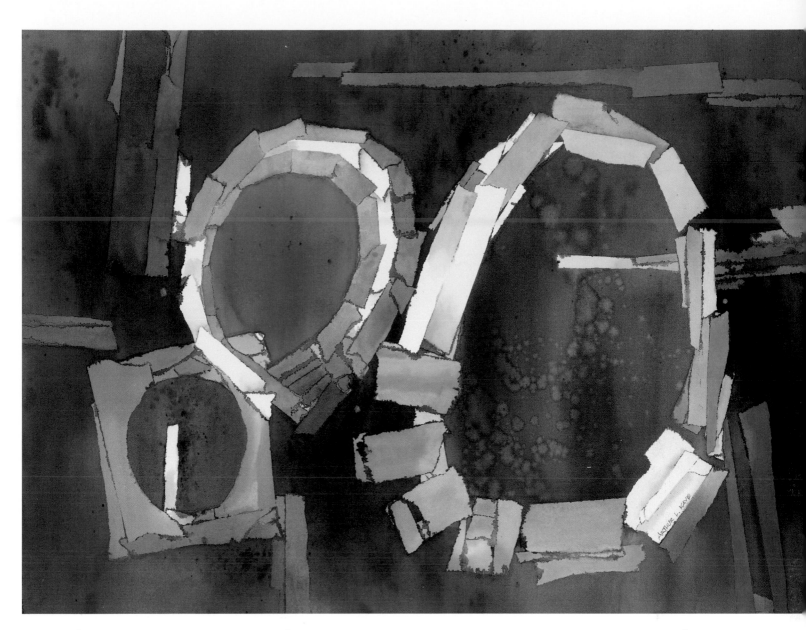

Back to Pure Watercolor

Crescendo
29" x 39"
Arthur L. Kaye

Motivated by a desire to enter those few exhibitions that insist on "pure" watercolor, I recently decided to attempt to produce works in that medium, which would be similar in appearance to my paintings in acrylics seen in *Splash 1*.

I utilize essentially the same methods I had previously employed, i.e., covering selected areas with drafting or masking tape and then painting the background with freely applied washes, spatterings, etc. to establish the initial phase of a work. I try to make certain that the background is really complete before removing the masking.

I then concern myself with the exposed areas, carefully selecting colors of harmonizing or contrasting hues, tints, shades and tones.

Along with the change in medium, I found myself using circular forms in addition to the usual horizontal/vertical format of my other paintings, and my new works have found acceptance in a variety of water-media exhibitions. To date, I have not had the opportunity to enter a "transparent only" show.

Arthur L. Kaye

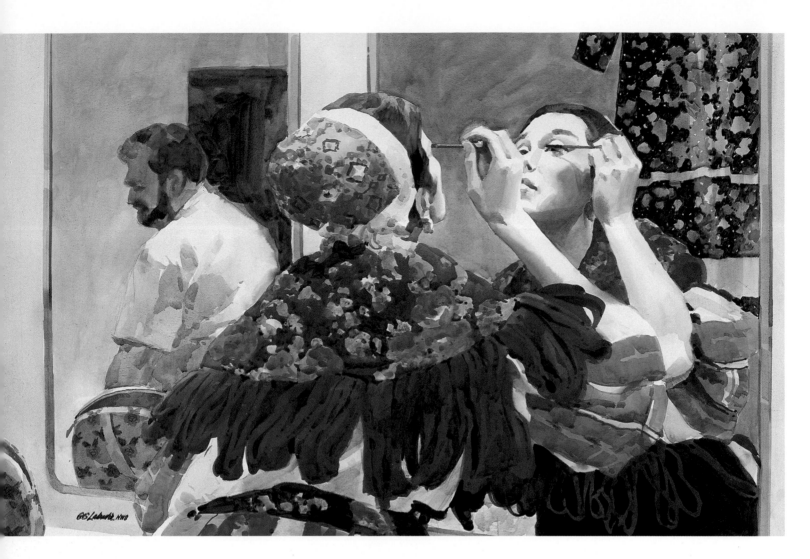

GS Labadie, NWS

Ten Minutes to Curtain
25" x 29"
George S. Labadie

A Change to Hot-Press Paper

Long a devotee of painting in transparent watercolors, the medium compatible with my temperament and personality, I sought to exploit its virtues to the fullest in my work.

Just a few years ago, not totally satisfied with the results I'd been having, I decided to try a large sheet of *hot-press* watercolor paper.

I anticipated some difficulties with the smooth, hard finish, but the results were, to me, exciting. The range of color, from brilliance to subtle darks, was increased tremendously, giving me variables I had never had before.

Greater reflection off the hard surface, back through the pigments to my eye, markedly increased luminosity in full light situations and added new dimensions of richness and vibrancy in half and deep shadow values.

The simple change to a smooth surface has proven to be a most significant and soul-satisfying breakthrough in my paintings.

Next (at right) is a simple caricature of my barber in his shop displaying a warm, friendly presence. Nothing indicates he's actually a self-made millionaire (not from barbering, though)!

Being on the spot for the opening of a performance, I wanted to catch the hurried last minute touch-up to makeup, prompted by the stage manager, in *Ten Minutes to Curtain*. I was also interested in the elegant costuming.

GS Labadie

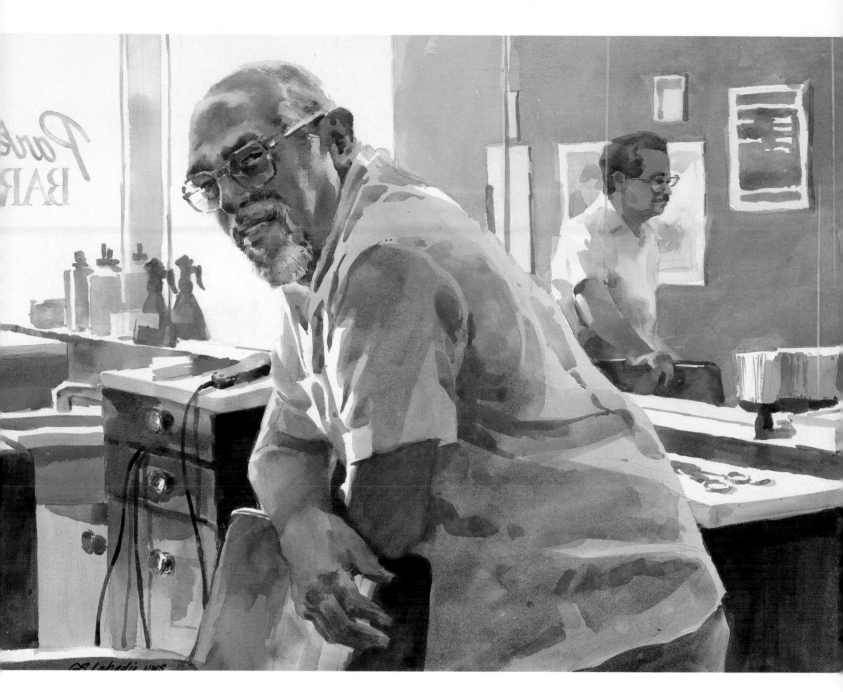

Next, 21" x 29", George S. Labadie

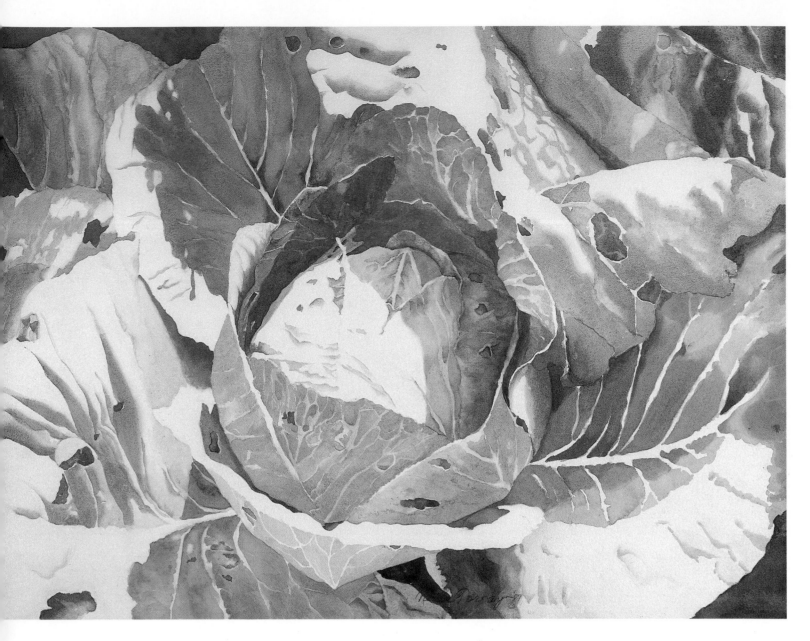

Cabbage
22" x 30"
Nedra Tornay

Fit the Color Palette to the Painting

I painted for several years using pretty much the same palette of colors I was told to buy when I took my first watercolor class. When I finished a painting, I felt there was nothing outstanding or unusual about it.

My personal breakthrough happened after I made a comprehensive study of the behavior of the various pigments and the characteristics of each tube of paint. Since I use mostly Winsor & Newton, I concentrated my efforts on this particular brand of watercolors. This study was very exciting and led to some wonderful discoveries.

I then decided to fit the palette to the painting by utilizing the special characteristics of the paints that fit my particular subject matter.

My first painting using my new arsenal of information was *Cabbage*, which almost painted itself. It was such a joy to see all the exciting things happening! My palette for *Cabbage* was manganese blue, aureolin (cobalt yellow) and scarlet lake. The manganese blue separated and created the texture of the cabbage leaves, the aureolin neutralized the blue where needed, and the scarlet lake warmed areas and darkened values. Aureolin and scarlet lake are both transparent colors and mix well with other pigments.

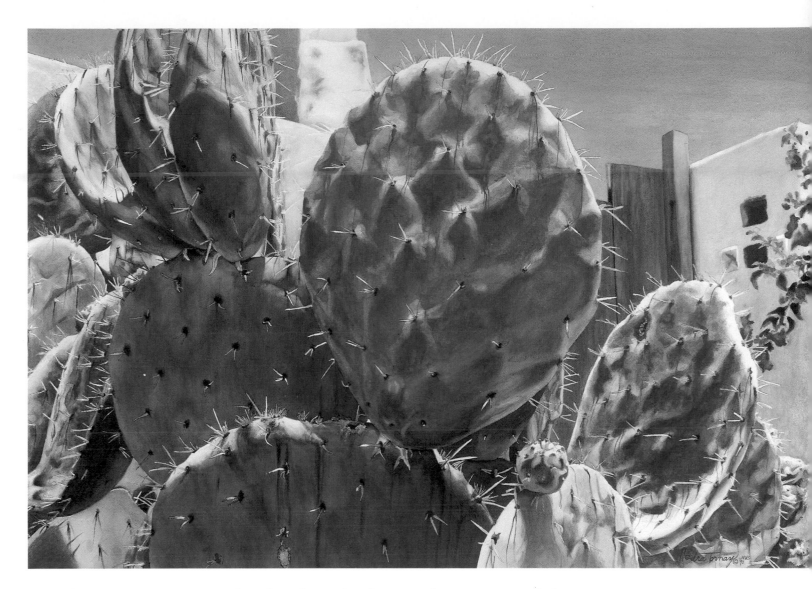

This painting won some awards and was featured in the September, 1990 issue of *The Artist's Magazine*.

I find that limiting my palette to three or four tubes of paint (red, yellow and blue), selected for their idiosyncrasies with regard to the subject matter, contributes to a unified and successful painting.

For *Cactus II*, I used Prussian blue. It is a permanent but fluctuating color that fades in the light and recovers in less light, which is very similar to what a live cactus does.

Cactus II
26" x 38"
Nedra Tornay

Nedra Tornay

Necessity, the Mother of Invention

This is a short description of something that happened to me in my early thirties. It not only influenced, but totally revolutionized my creative development.

At that time, I was already selling my conventional watercolors for a little more than it cost me to produce them. One beautiful October weekend, a watercolorist friend and I borrowed a cottage in Ontario's wonderful Algonquin Park area. Friday evening we arrived and proceeded to unpack. At this time, I realized that I had left my painting gear at home. Needless to say, the weekend looked pretty gloomy for a while.

After my friend stopped laughing, he declared that he was in no mood to go back home. He then offered to share whatever extra supplies he had with him.

He needed the only pencil he had. He gave me a few sheets of mounted Whatman boards, which I cut into quarter-sheet sizes. I also borrowed a small palette knife, a couple of 1-inch slanted bristle brushes, a no. 10 round sable and a small rigger. A dinner plate from the kitchen shelf became my palette after I squeezed onto it blobs of watercolor paint from my friend's supply of tubes. Needless to say, the paint was dry by the morning. With the help of a couple of plastic freezer containers for water, the next morning we were off to paint the colorful autumn landscapes surrounding us.

That day—because necessity forced me to break away from my familiar technical habits—I discovered an entirely new approach to painting watercolor. That was the day I started to paint without pencil drawing. Also, for the first time, I used a palette knife for transparent liquid watercolor. And that day was when I got excited about wet-into-wet shapes painted with a firm, slant-edge bristle brush.

These new tools have totally changed my established conventional style and turned it into a new individualized format. At last I was painting my own ideas, with feeling, my own way. Necessity was truly the mother of invention.

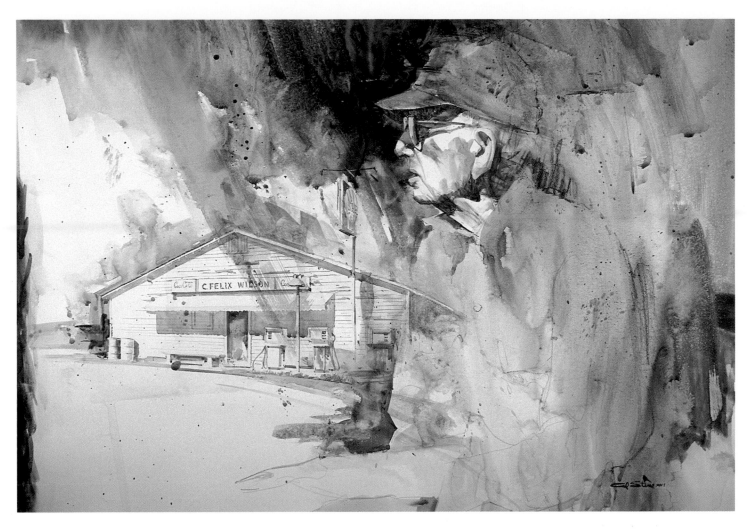

Experiment With Bristol Board

Mr. Wilson
28" x 36"
Al Stine

I had one of my bigger and most thrilling breakthroughs a few years ago when I began experimenting with plate-finish Bristol board and kid-finish board. There was really nothing new to me about these surfaces, as I had used them for years in illustration work, but using them for watercolors was a new challenge. I began experimenting with portrait work on these finishes and after many unsatisfactory results, I began to achieve control of color and "accidents" and became excited by the results, especially with the Bristol board.

In the figure studies I am now doing, I strive for strong value patterns and a loose ethereal feeling. A good example is the portrait I did of an old gentleman, Mr. Wilson, who owned and operated the same gas station in the same location for sixty-five years. *This painting was my breakthrough!*

I wanted to capture Mr. Wilson and his station that was so much a part of his life, so I incorporated both in the same painting. In this painting, as in subsequent portrait work, I tried to include something personal in the work. I didn't complete all the detail, but rather kept the painting loose, allowing the viewer's eye to complete the painting. The results of this technique have been well received. As much as I paint and teach the more traditional methods of watercolor, it is the time I spend experimenting that is most exciting and stimulating. Who knows, next week I may make yet another big breakthrough.

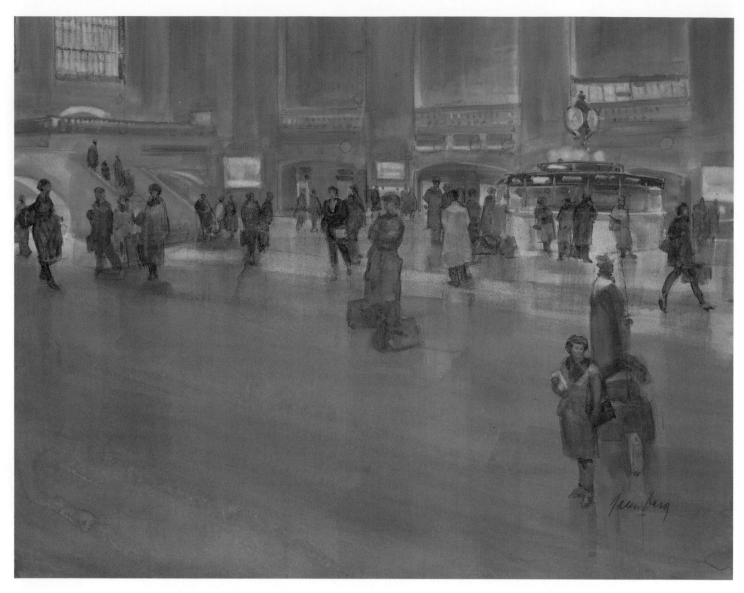

*Grand Central
Station*
11" x 14"
Irwin Greenberg

Flexibility With Plate-Finish Bristol Board

About ten years ago a former student and I were painting from a model in my studio—he in watercolor, I in oils. At that time I was working mainly in oils, out of a feeling of frustration with the limits of watercolor. I had never successfully worked from a model in watercolor, and I felt that even in my landscape paintings there was a little too much eyewash, too much of the swashbuckling, rah-rah style of watercolor painting and not enough real study. At all events, as we worked I peeked over at what Joe, the former student, was doing.

It looked interesting. He had broadly laid in the picture with different colored washes flowing into each other. I wondered how it would develop. I went back to work on my painting but kept glancing over at Joe's picture. I saw that the forms had started to gel and that he was taking out passages, modifying and correcting without losing an essential organic unity. He had trouble resolving some areas because of drawing problems, but what he came up with was a structure—all worked out without relying on line.

When he stopped work, we discussed what he had done. He had studied with Burt Silverman, a painter whose work I had admired for some time. Burt, he told me, recommended a plate-finish Bristol board as the surface. The paint lays on the surface and can easily be wiped off with a wet paper towel wrapped around your index finger when an area needs to be corrected. In addition, a little white was added to the color, which also helped in the wiping out process. The result was a solid, atmospheric, tonal painting.

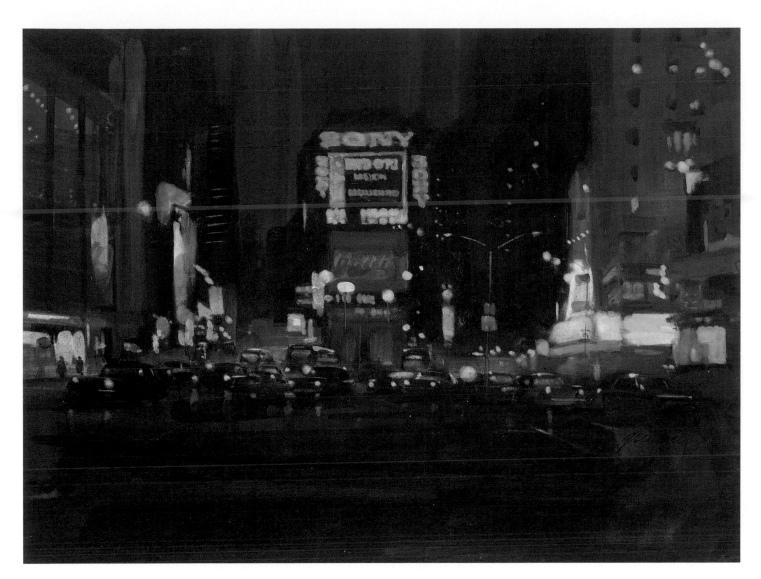

Times Square
Nocturne
11" x 14"
Irwin Greenberg

It was a revelation. I bought some Strathmore Bristol board (I find 5-ply the most satisfactory), cut a sheet down to smaller sizes, and started to work. It took a few failures to get the hang of things, but soon I began to see the possibilities. I could never have done *Grand Central Station* on conventional watercolor paper. I kept taking out and putting in figures, something I was never able to do before.

Since then I've been working mainly in watercolor on plate-finish Bristol board. It is endlessly fascinating. I can tackle subjects that I'd once avoided because conventional watercolor paper doesn't allow for the take-away and put-back that enable corrections to be made—or causes the corrections to look labored when they are made.

Being a New Yorker, I'd always felt challenged by the look of the city. Now, for the first time, I could work out the construction of buildings, store fronts and autos, as well as the frantic activity of the people. In addition, I now do work from a model in watercolor and teach it to students in my classes at the School of Visual Arts.

Irwin Greenberg

2
Technique

I believe that an artist's life is a continuous series of breakthroughs—learning to competently use various media and moving from plateau to plateau in terms of skill and understanding the content of one's work.

—LINDA STEVENS

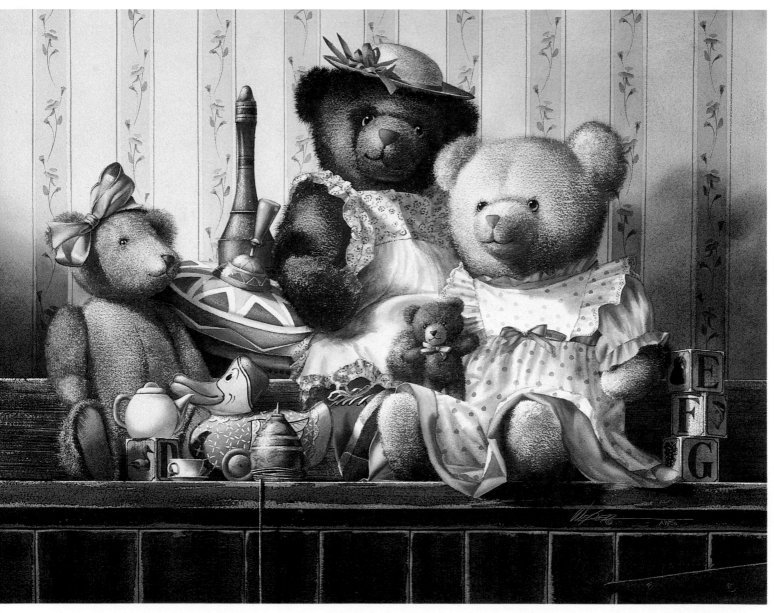

Tea for Three, 22" x 28", Michael J. Weber

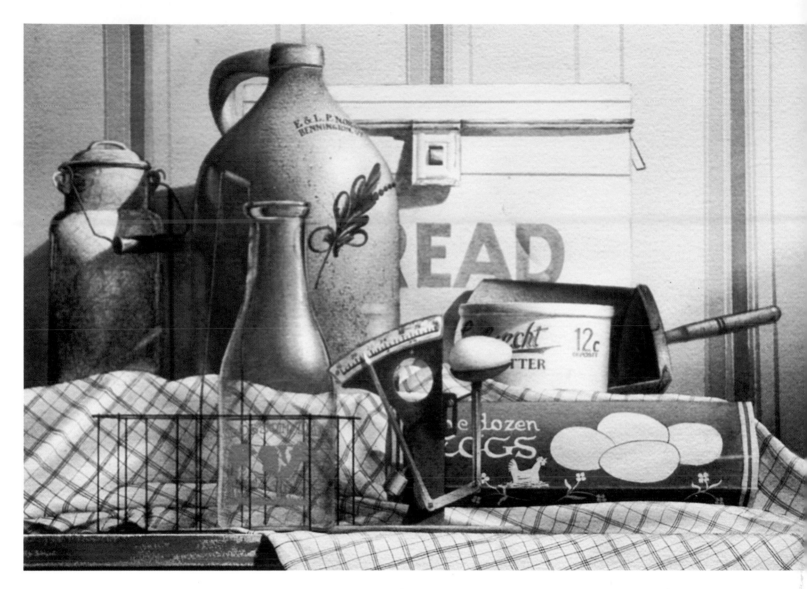

Achieve Texture With Dry Brush

Fresh Eggs
22" x 28"
Michael J. Weber

Concentrating on dry-brush technique to achieve a sense of texture in my painting has been a great personal breakthrough. By also following the principles of contrast—light against dark, warm against cool, and hard against soft edges—I have been able to reinforce my feeling for texture in watercolor.

I work on 300-lb. Arches rough paper. The texture of the paper helps me achieve a dry-brush effect. I mix my colors strong enough to get rich color on the first application. I rarely use thin glazes to achieve a desired value. If the object I'm painting has lots of texture, I begin with a wet-on-wet underpainting. When the paint is dry, I use a dry-brush technique on top to bring out the surface texture of the object.

Dry-brush technique works well as fur in *Tea for Three*. The rougher texture sets up a nice contrast with the bears' soft clothing.

In *Fresh Eggs*, I used the soft fabric interwoven around smooth, clear glass, spatterware and other kitchen objects to emphasize texture.

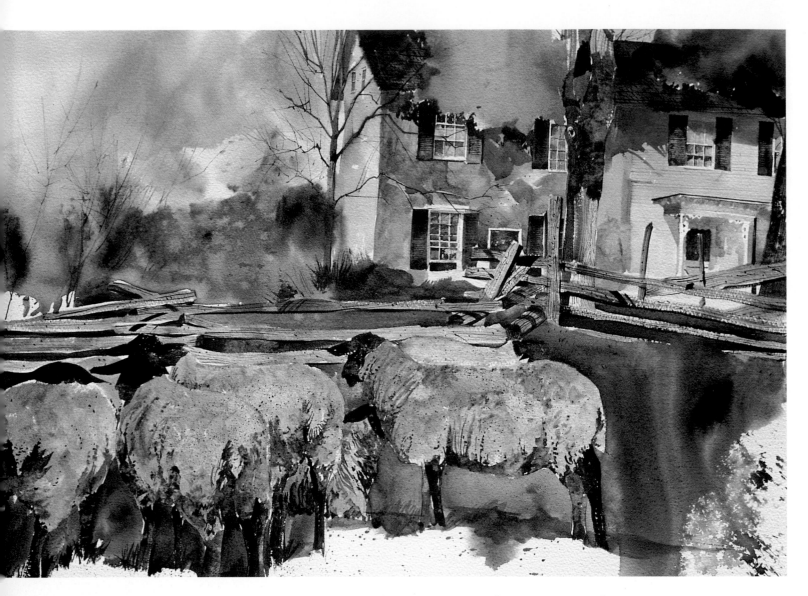

The Gathering
22" x 30"
Robert Sakson

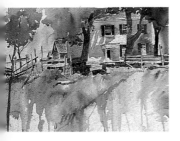

Howell Farm
20" x 24"
Robert Sakson

Hang Your Realism on Abstract Shapes

My greatest breakthrough would be the way in which I present my subject matter rather than actual technique. When I first started painting, I worked toward a strong play of dark and light, experimenting with strong shadows using Payne's gray, Vandyke brown, ultramarine blue and Winsor violet. In some of my later work, I started surrounding the subjects with abstract shapes to hold them in the painting, forming a sort of vignette. I feel it is not always necessary to continue detail beyond the center of interest. I have repeated this in many of my recent compositions, including *The Gathering*. I have included the watercolor sketch for *The Gathering*, called *Howell Farm*, so you are able to see the progression from on-location painting to the finished work. The sheep were scattered around the house, and I reorganized them to the positions where you see them.

I allow my thinking plenty of room, always using an abstract series of shapes to "hang" my Realism on. Everything we see is made up of abstract shapes.

Painting from nature is the best way to keep your "artist's eye" fresh. I paint every day on location in central New Jersey around the Delaware River, in all seasons and weather conditions.

Robert Sakson A.W.S.

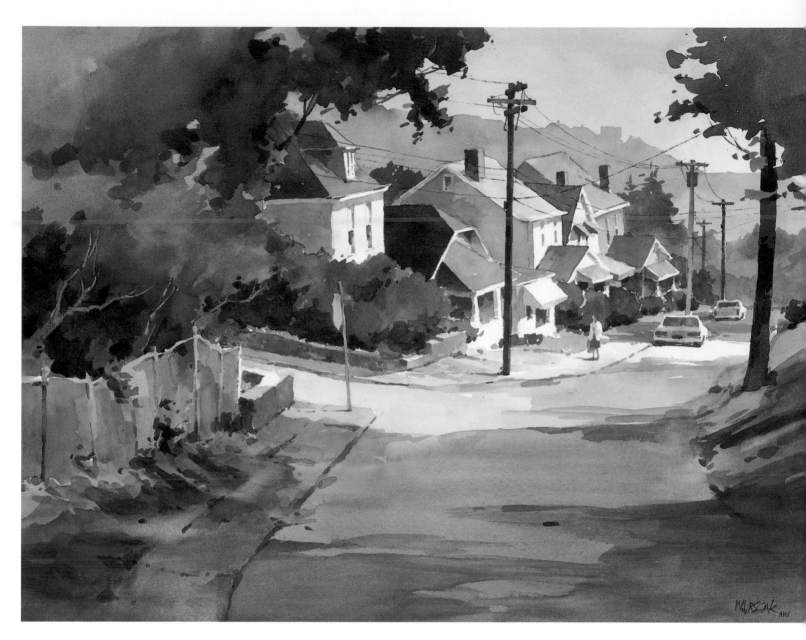

Brookline Morning
21" x 29"
William M. Vrscak

Simplify Complex Subject Matter

I believe an artist experiences many breakthroughs during his or her development, and I certainly have had my share. An important breakthrough for me came when I learned to simplify complex subject matter by translating it into large, simple shapes and planes. This enables me to establish a form's basic structure right at the beginning and to determine how far to develop the subject without so many lesser planes and details. It means every stroke counts. It's a method that works especially well with watercolor, since it promotes an economy of brushstrokes, which helps keep the painting from becoming overworked—the bane of any watercolor.

I have become a great advocate of simplicity, not only in technique but in concept and design as well, eliminating all but the most essential visual elements necessary to complete a statement. This "making every stroke count" technique often enhances and adds strength to a simple, uncluttered composition.

In *Brookline Morning*, interest is focused on the central area of interlocking planes of roofs and awnings by containing it within a large, dark-value foreground. Contrast in the foreground is forbidden to avoid competition.

W. Vrscak

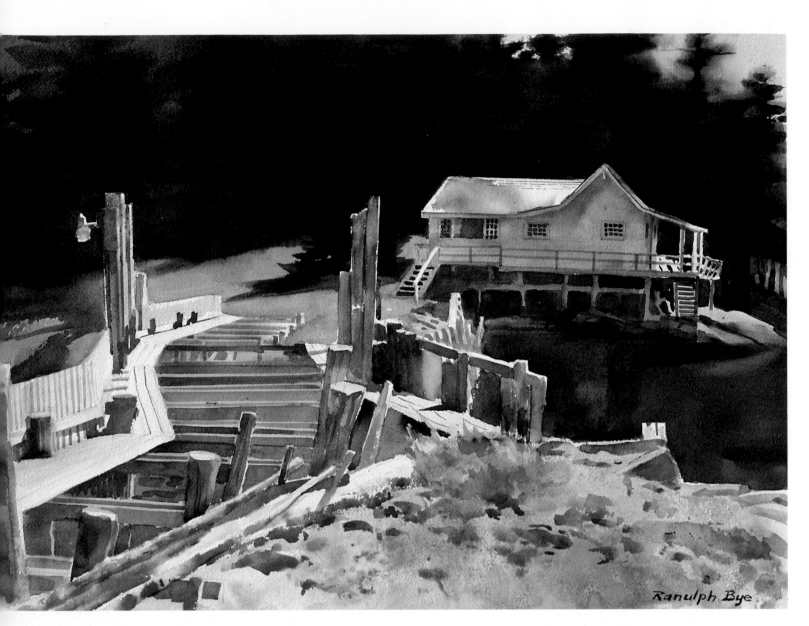

Textured Surface With Oil Color and Turpentine

I do not feel there has been a sudden breakthrough in my painting career but, rather, a gradual development over the years. In looking back to my early work, I was mainly concerned with interpreting a subject visually the way anyone would see it. I am now becoming more aware of what good composition and design can achieve in making a painting more alive and organized.

Texture of surfaces is playing an important role in my watercolors. I was fortunate in knowing a fellow artist (now deceased) who achieved a certain patina on the paper. With a mixture of oil color and turpentine on very wet paper, he created a fascinating and free-flowing area very suitable as an underpainting for gravel, stone, masonry and grassy areas. This technique I have used in many of my works for twenty years, including *Foundations*. Surprisingly this method is not incompatible with the watercolor medium. It has enabled me to achieve many subtleties of tone and simplification of forms not evident in my early work.

Watercolor painting is a continuing struggle to reach perfection; only rarely does one feel the goal has been attained.

Ranulph Bye

Foundations, 21" x 29", Ranulph Bye

Three Soldiers, 15" x 22", Alex Powers

Golf II, 17" x 26", Alex Powers

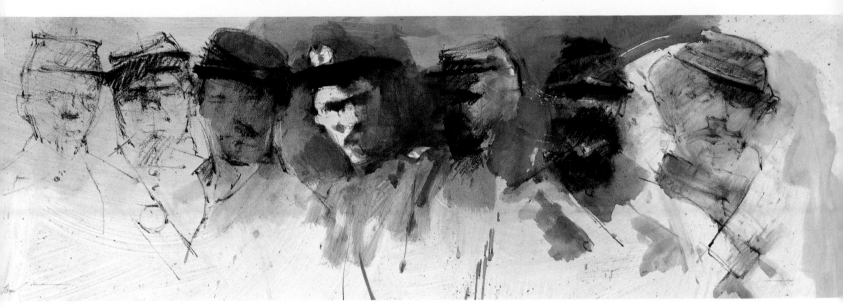

Civil War Soldiers
13" x 39"
Alex Powers

Couch Potato Art

I prefer painting from subject matter. Making up images and manipulating painting materials to create abstract shapes and textures are a great way to paint, but they are not for me. I need exciting source material for my initial inspiration for each painting.

In my earlier years I painted landscapes on location. For practical reasons, in addition to painting on location, I painted from slides. When VCRs and camcorders became common, the potential for source material for artists greatly increased. Earlier, when I was photographing a model, I would take three or four shots of the model's pose. With a video camera, an artist can tape views looking down, at eye level and looking up; as well as close-up and from distant perspectives, making the camcorder much more versatile than the still camera.

I have painted for several years using videotape that I have recorded this way. I have just begun taping programs from network and cable television for use as source material for painting. Of course, a camcorder is not required when taping directly from television programs. The Civil War paintings reproduced here are from educational television's fine "Civil War" series. The three sequences of a golf swing in *Golf II* were painted from a network TV golf program.

I have a traditional art education. The unwritten motto was, and is, "Curse the New York avant-garde. Paint meaningful truth and beauty." Does painting from network and cable TV denigrate meaningful truth and beauty? I think not. Of course, it depends upon the attitude of the artist.

Television's endless imagery needs to be screened through the artist's eye. Work produced from television should be consistent with the artist's current style preferences. Let TV's imagery be a tool to initiate the excitement for painting. Limit being a "couch potato" to gathering source material. Arise and paint with all the care, craftspersonship and creativity that you know a masterpiece demands!

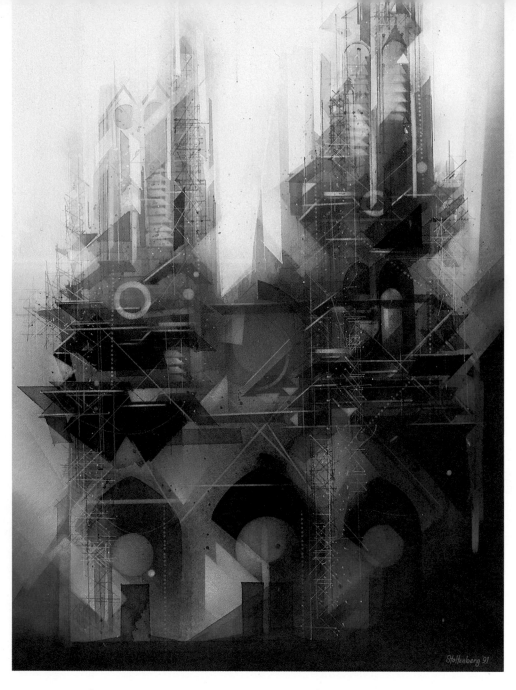

Restoration
29¹/₂" x 21¹/₂"
Donald Stoltenberg

Stencils Create Space and Form

Many years ago while experimenting with watercolor techniques, I came upon the use of stencils. I found that by using a damp, foam rubber sponge through ready-made letterform stencils, paint could be removed from a dry area in a very precise way. Best of all, by doing this repeatedly with overlappings and uneven sponging, an unexpected and very rich articulation of space and form could be quickly achieved!

To this subtractive technique I added the more conventional additive one—applying paint with the sponge through the stencil. Together these techniques produced a complexity of form and definition quickly, which allowed much more exploration with greater confidence.

The next step was to make my own masks and stencils in the most useful shapes—such as L's, a pair of which can combine to make any size rectangle or triangle. I cut circles, arcs and straight strips to produce a great variety of shapes.

By varying the dampness of the sponge or the pressure put on it when wiping out paint, tonal gradations are possible. These methods combine well with wet-in-wet (soft edge) painting, contrasting sharp definition with amorphous form. They have become fundamental to my way of working with watercolor.

Stoltenberg

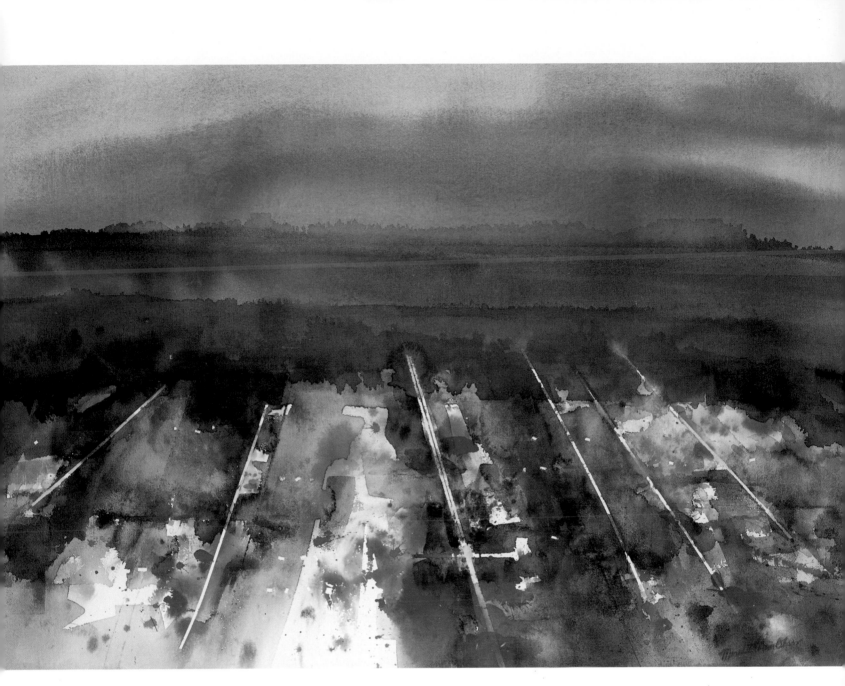

Wonderview
20" x 28 ¼"
Meredith Ann Olson

Using Tape as a Masking Agent

My paintings reflect my continued interest in landscape imagery and in the changing effects of light and atmosphere. While the inspiration comes from nature, the breakthrough comes in the studio during the process of painting, when I go beyond surface detail to capture a particular mood or essence of the landscape image. My breakthroughs evolve through experimental approaches. The image and desired effect direct the choice of technique.

The transparent watercolor *Wonderview* was inspired by the view from our home at sunset when the lights of the city were beginning to appear. The breakthrough came with the use of tape as a masking agent to create the crisp white lines of the city lights to contrast against the washes of atmospheric light and color. Other techniques I used included wet-in-wet, wash, glazing, direct brush and splatter.

The source of inspiration for my current paintings is a sketching trip to Yellowstone National Park. Previous breakthroughs, such as the one described above, provide new avenues of adventure to capture the chromatic splendor and effusive vapors of Yellowstone's hydrothermal areas.

Meredith Ann Olson

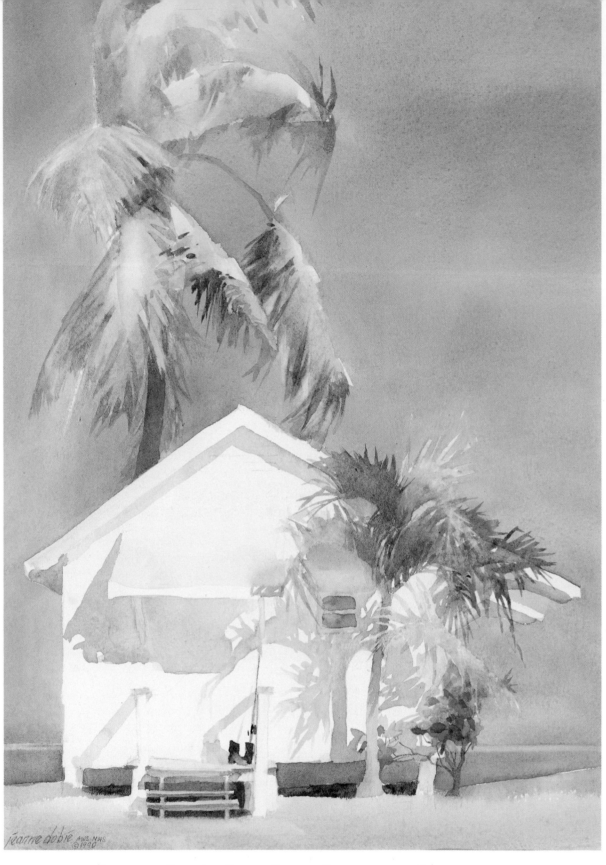

VIP Cottage
14 ¹/₂" x 10 ¹/₂"
Jeanne Dobie

Two-Color Value Sketches for a Light Pattern

I am using and teaching a different method of value sketching that dramatically improves a watercolor by extracting a light pattern.

For several years, I have been immersed in pursuing one facet of painting that intrigues me most—developing optically glowing lights, which are so beautifully inherent to watercolor. Similar to taking a composition apart and reconstructing it into a stronger design, I divorce my light shapes from the rest of the composition and reconstruct them into an eye-catching pattern.

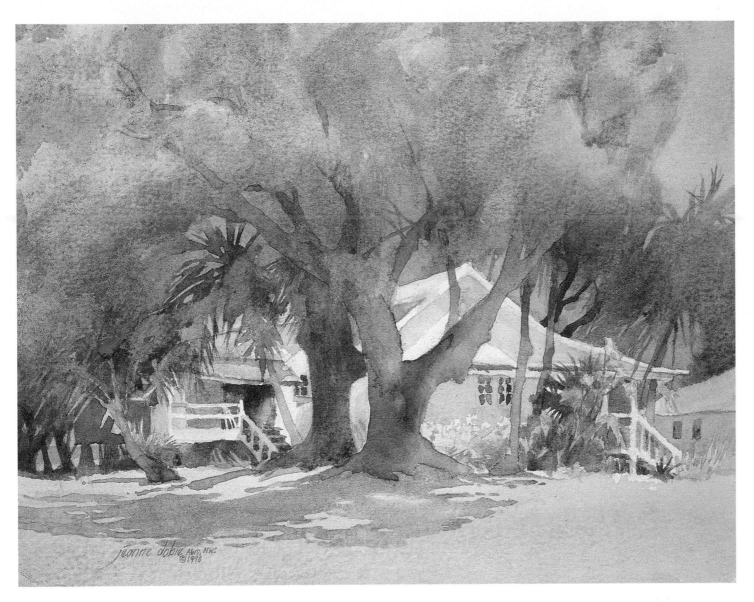

Pigeon's Roost
8 ½" x 10 ½"
Jeanne Dobie

My breakthrough came when I conceived the idea of painting my value sketches in two colors instead of the usual black, white and grays. I used yellow for the light value and blue for the remaining values, middle to dark. Because yellow is a tentative pigment and will not produce a dark value, light areas were painted as positive images and preserved automatically! By using a color to describe light areas, I was channeled into "thinking" in shapes of light and "considering" patterns of light that elevate a composition beyond the usual. With my new method, I found that light areas could be redesigned easily. If I was dissatisfied with a light shape, I could change it by simply washing the blue color over it. The light pattern remained, distinct and clear. Since I developed this method, my watercolors have been quickly organized not only into values, but strong light and dark patterns as well!

In *VIP Cottage* I decided to keep the reflected light lighter than usual to retain the impact of the major light shape. In *Pigeon's Roost* I defied the rules of "safe" composition by placing a dark area directly in the middle. Here, the light pattern becomes crucial. It must be exquisitely designed to divert the viewer's attention from the intruding dark areas.

Why is a light pattern so important? It is a fact of human nature that we notice light areas first, rather than dark areas (one of the reasons the hero or heroine on a stage usually is dressed in white). Therefore, if the viewer is going to be attracted first to the light shapes in a painting, my method gives an artist the opportunity to distinguish his or her painting with an exciting light pattern, and treat the viewer to something extraordinary!

jeanne dobie
A.W.S., N.W.S.

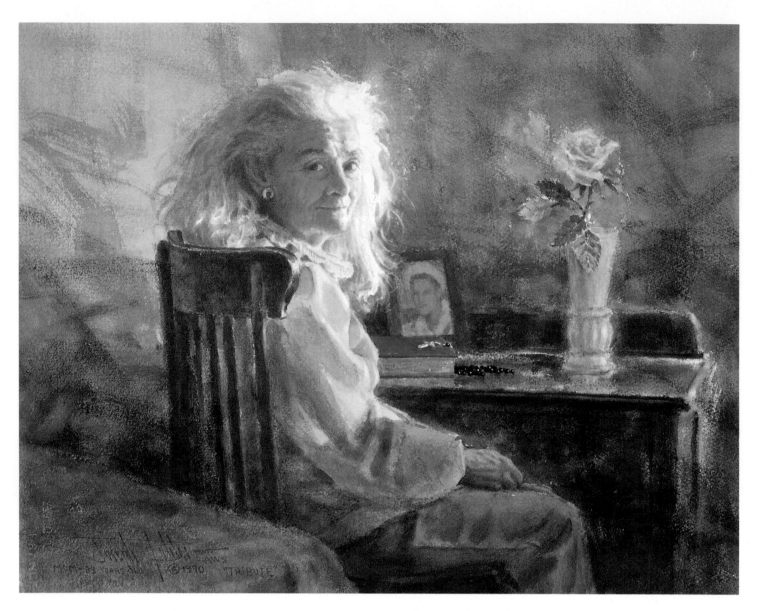

Tribute
17 ½" x 21 ½"
Joseph Bohler

Fill the Painting With the Figure

For me, my fine art career has been filled with a series of breakthroughs since I began painting full time about twenty years ago. Studying and painting with John Pike, Robert Lougheed and Richard Schmid has helped guide me toward my goal of excellence in art. When I began to enter national shows, accepting rejection and using it as a positive motivator was one of my earliest breakthroughs.

Recently, I've discovered some breakthroughs for suggesting *feeling and mood* in my figure work by using light, simple backgrounds and filling the painting area with the figure. An example is the painting, *Tribute*. The painting has a simple background with the focus on the figure. Additional feeling was created with the use of the yellow rose and a photo of a son lost in war. The brush and sponge technique was used to make the simple background, so the viewer can become totally absorbed in the figure.

Another technique to evoke feeling and mood is painting the subject looking directly at the viewer! Feeling and mood are elusive words in our artistic vocabulary, but they are very important.

By the way, the woman in the painting is my mother.

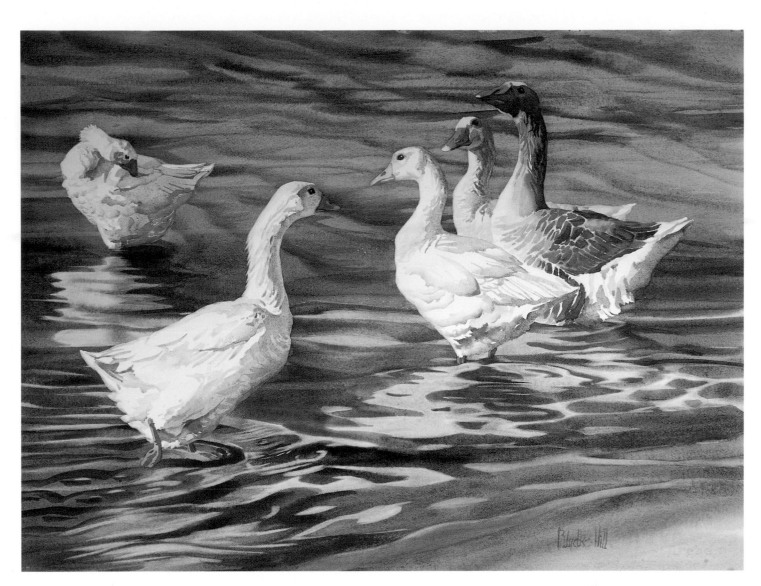

Shallow Waters
22" x 30"
Barbara Luebke-Hill

A Great Way to Paint Feathers

I love to paint animals and birds, which I try to do in a painterly way, avoiding a tight, scientific, rendered look in favor of artistic expression and impression.

When I first tried painting ducks and geese in transparent watercolor, I experienced a lot of difficulty in situations where the birds were close up and required some explanation of the characteristics of their feathers. I struggled with this depiction in watercolor, trying to show that they were indeed feathers, while keeping my painting sufficiently loose, interpretive and expressive.

My breakthrough came, through trial and error, when I suddenly realized I could quite adequately show the shape and character of feathers not by rendering every feather, but rather by suggesting feathers. I have done this in several ways, as seen in *Shallow Waters*.

One way was to paint positively; that is, paint the feather or group of feathers with the brushstroke itself. Another way was to paint only the shadow side, where the feathers turn under, starting with a soft edge and ending in the shadow with a hard edge. An additional technique was negative painting, painting around the feathers to depict them, leaving them unpainted. Another method was to paint the creases or breaks in feathers to show a textured area. In some instances, just a suggestion of feathers was indicated with a simple brushstroke.

It seems to take putting all of these different ways of painting feathers together to make a convincing creation. Also, using variety in the method of painting the feathers keeps it interesting. I realized that I was achieving my goal by painting less, with knowledge, to show more!

B. Luebke-Hill

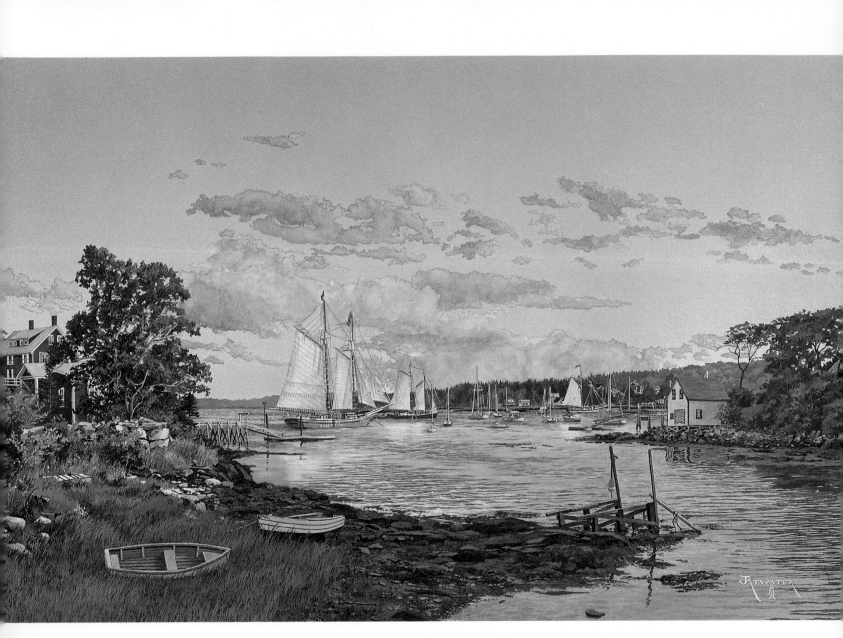

Christmas Cove
22" x 34"
John Atwater

Rescuing a Watercolor With Gouache

Christmas Cove began as a traditional transparent watercolor. Halfway through the painting I realized that the foreground marsh grass and the right clump of trees had become too dark and muddy, while the rest of the painting held together quite well. Rather than pledge my blind allegiance to the sole use of transparent watercolor, I decided that the finished painting would be much improved if the dark areas could be blotted and repainted.

So, that's what I did, with gouache (opaque watercolor). Continuing with opaque watercolor, I painted the foreground rowboats, added reflections in the water, and made subtle improvements throughout the painting, thereby changing my "code of ethics" from "only transparent" to "whatever medium will produce the best results."

Leaving Monhegan was designed with three specific focal points: foreground flowers, middle ground landscape/harbor and distant cumulus clouds. These three areas are held together by the repetition of the pink, blue and white color scheme.

John Atwater

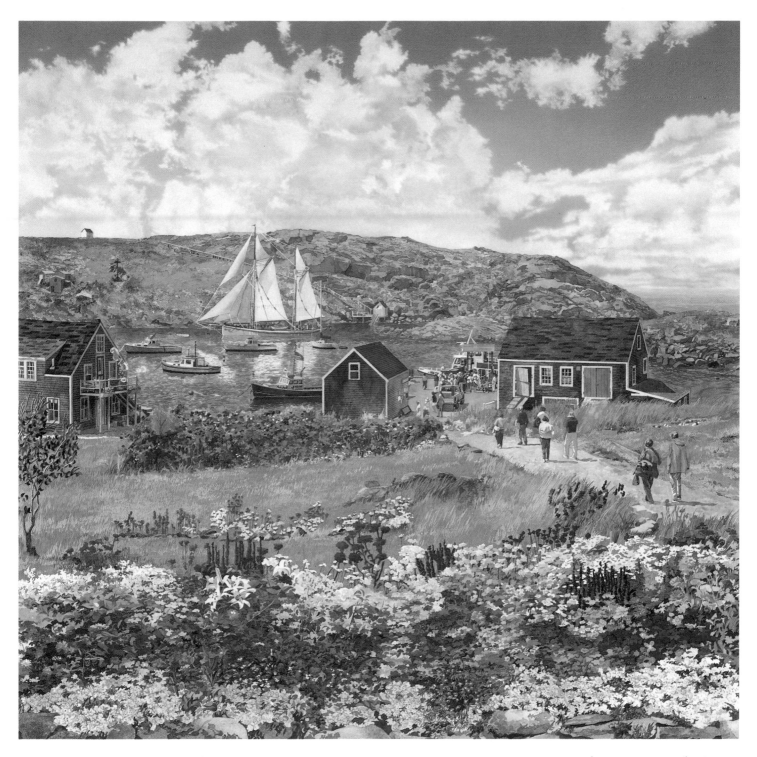

Leaving Monhegan, 37" x 37", John Atwater

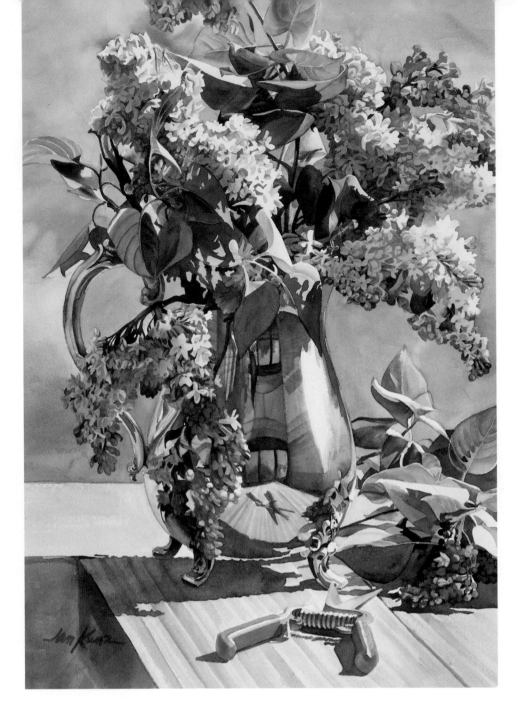

Lilacs and Silver
28" x 20"
Jan Kunz

Stop and Think

I have had several artistic breakthroughs, but the one I remember most vividly happened years ago. During this time of my life I held a full-time job and had two children at home. Painting watercolors was my joy and recreation. The breakthrough happened after the local watercolor society asked me to do a demonstration painting. This was to be my first, and I was determined to do a good job.

After convincing my family I needed a weekend to myself, I selected a simple composition and settled down to practice the painting again and again to gain confidence. After about my seventh try, it happened! The light dawned and I could see that my last attempt was no better than my first. There was no progress. I was repeating the same mistakes.

Something said, *"Stop and think!* How can you improve this painting? What shapes can be better? How can color be better used? How can an edge be improved?"

Breakthroughs come in flashes of insight that guide and instruct. This experience has truly changed the way I paint. Now I plan each painting with "stop and think" sketches. Shapes, edges, value and color have become more important than subject matter. Finally, I have learned to see.

Jan Kunz

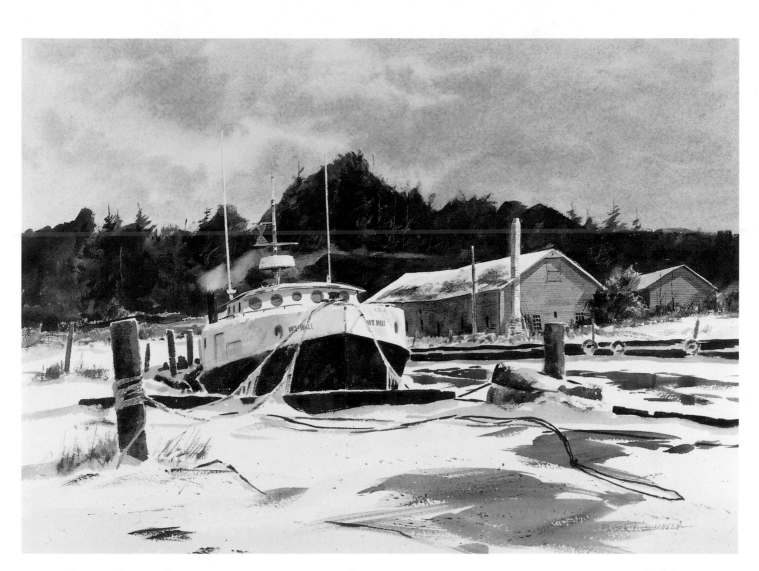

Daily Sketching Is a Foundation

I had been painting for many years, experimenting in oils, casein and tempera. The resulting paintings were good, but I was not satisfied. Fortunately, I then began to paint with watercolors; immediately I found them exciting, alive, dramatic and more sensitive to my brush. Watercolors have spontaneity; they challenge the artist. They are not easy, but I love them. My introduction to watercolor is really my personal breakthrough in artistic expression.

Primarily a landscape painter, I am influenced by nature and my surroundings. I sketch daily. These sketches are the foundations of my paintings. This approach establishes direct contact, an interaction with the subject that cannot be achieved with a camera. I believe in "pure" watercolor, no opaques to cause loss of "sparkle."

It takes years of disciplined sketching and painting to achieve the skill, confidence and personal technique to paint accomplished watercolors. You must create your own identity, and it doesn't come overnight.

Robert Johansen

Sand Bay
18" x 25"
Robert Johansen

Drawing of Sand Bay
Robert Johansen

IN MEMORIAM

Robert Johansen passed away during the production of this book after an eighteen-month battle with cancer. Three of Bob's paintings were featured in *Splash 1* and he was honored to know his work would also appear in *Splash 2*. Bob leaves a widely appreciated legacy and his paintings will continue to bring beauty into our lives forever.

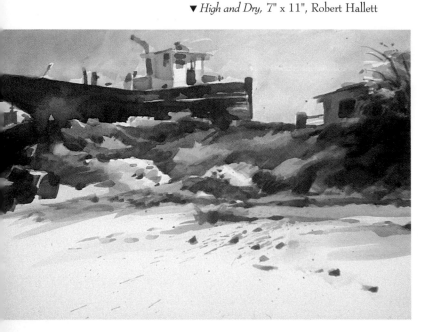

Refitting
7" x 9"
Robert Hallett

▼ *High and Dry,* 7" x 11", Robert Hallett

Crystal Cove, 5 ¹/₂" x 9", Robert Hallett ▶

A Wash Sketch Solved the Problem

The breakthrough described below began as a result of the frustration I felt when teaching college classes and watercolor workshops on location in southern California. I feel that experienced students as well as beginners should make a composition sketch or value sketch before they attempt a painting. The traditional sketch medium is pencil, and most painters use it. Thirty years of demonstrations and pointing to visual aids always brought the same results. Students do not seem able or willing to make a pencil sketch in which the values have any contrast. They draw outlines and make miserable attempts at toning them in. Without contrasts and a definite value pattern, the sketches were anemic and usually a waste of time.

After trying everything I could think of, I discovered that a wash sketch solved the problem. It not only provided a working design, it made an easy transition from drawing to painting—since the wash sketch and the painting were both made with the brush. The sketches are done in a neutral tone, such as sepia, burnt umber or black. The time spent should be from fifteen to thirty minutes, and they should be from postcard size to 7"x10". They can be done on cheap drawing paper, sketchpads or scraps of watercolor paper. This method has worked so well that I use it myself. It has also greatly improved my students' paintings. I usually make a rudimentary line drawing with a pointed brush and wash. Then I determine where the white of the paper should be saved for the lights. A quick wash in mid-light tones covers everything but these white shapes. When this is dry, I overlay the mid-dark shapes and, finally, the dark accents.

The main danger here is not to get picky and niggle away. Just remember, it is only a rough sketch, but it gives you a crystal ball look at the finished painting. Unity is the goal.

Robert Hallett

Ideas Come as You Paint

In my experience, a breakthrough doesn't just happen! That is, a sudden vision or an idea out of the blue just doesn't happen. Hard work, experimenting with colors, mixtures and papers, as well as constant determination, will lead to breakthroughs. One evolves into a different approach, more expressive colors or perhaps simplification. Ideas come as a person paints, but we must be alert, open-minded and flexible to be able to use those ideas—"accidents" as well as deliberate techniques.

To create *Flea Market*, I was open-minded to one of those "accidents." I saw the model in a local laundromat and she was wearing these wonderful Pakistani clothes. I hired her on the spot to sit in a nearby flea market. All the furnishings you see in the painting were for sale.

My own breakthrough, I think, is in the future. What that will be I have no idea!

Marbury Hill Brown

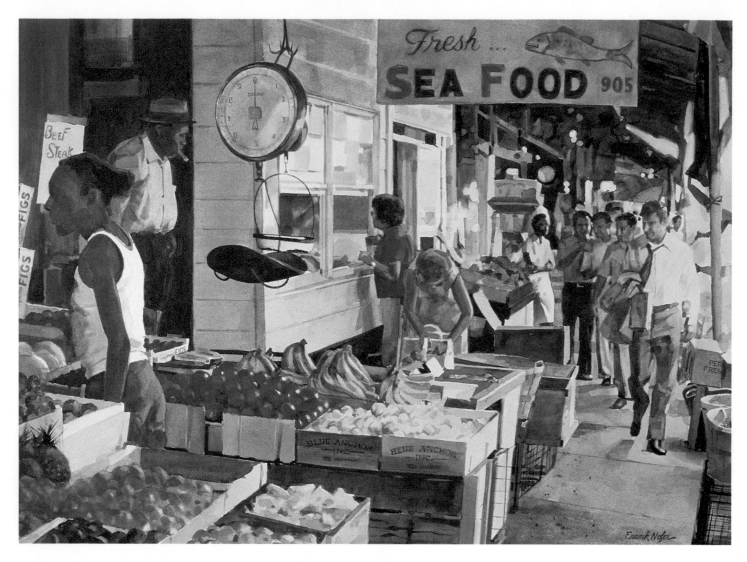

Italian Market
19 ¹/₂" x 26"
Frank Nofer

Give Yourself a Break

About a year ago, I perceived that an abbreviated attention span, waning enthusiasm and indecision were producing a mental block at the halfway point as I developed a watercolor. If we were talking baseball, it would be time to bring in a relief pitcher. So, it seemed appropriate that I adjust my painting modus operandi.

Since I believe I am an "impatient perfectionist," I decided to turn this somewhat contradictory personality trait into a plus. It occurred to me that my usual painting procedure was obligating me to concentrate from start to finish without letup. I was not allowing myself a break to consider the possibility of imaginative changes as the painting progressed. And the final brushstrokes were becoming a bit traumatic since I was striving for perfection while, at the same time, my impatience was dictating that I get the darn painting done.

Here's how I achieved what I regard as a real breakthrough. I decided to make a practice of painting several totally unrelated watercolors at the same time, alternating in addressing each painting in accordance with my mood.

Now, I research, sketch and plan one painting just as I have always done. Then, after a "breather," I conceive another totally unrelated watercolor and carry it to this same stage of development… and then do the same with a third, fourth or fifth painting. I may allow several of these initial concepts to rest in peace for as long as six months, but I'm always prepared to proceed with three of them at any given time. And when I do, I experience renewed enthusiasm and I feel the odds are with me that at least one of my efforts will result in a successful watercolor.

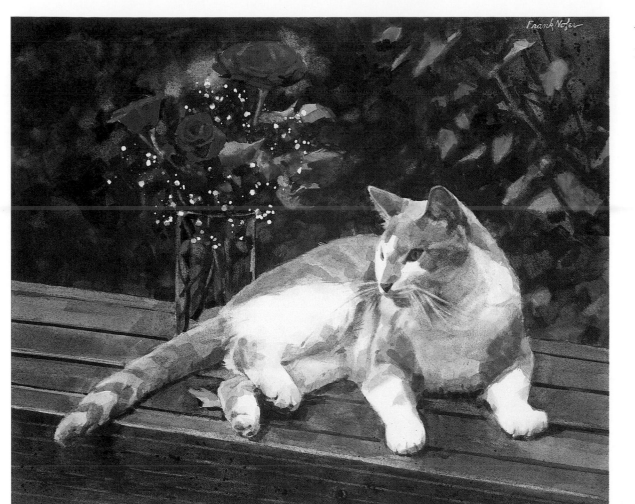

When it's time to apply paint to paper, if I'm in a bravado mood, I'll wash in the broad compositional shapes of one or all of the paintings. Next, if I feel decisive, I may work up one of the paintings until a hint of boredom or a lack of direction sets in. If the particular painting is monochromatic, I sometimes switch to a brightly colored watercolor. And as I advance each painting, I may realize that one of the watercolors needs serious conceptual or design modification. I don't hesitate to introduce dramatic change even if I chance ruining the painting—after all, I don't have "all my eggs in one basket."

With the new breakthrough approach, I never apply those final brushstrokes if I've been working on a painting for an extended period of time. The painting may be done and I'm too tired to realize it.

The recently painted *Guadeloupe Trio*, 17 ³/4" x 26 ³/4", *Nutmeg and Roses*, 12 ³/4" x 15", and *Italian Market*, 19 ¹/2" x 26", are three completely unrelated images. While they were all conceptualized at different times, they were all actually painted and carried through to completion concurrently.

I believe my breakthrough has improved my painting. I *know* it's increased my enjoyment. That alone is a good reason to dip one's brush in paint.

Yellow Line, 60" x 40", Louise Cadillac

Implosion
30" x 22"
Louise Cadillac

Break Through by Purposeful Struggling

Whether you stumble across it, have been struggling to find it, or someone points it out to you, the exhilaration of the find, the breakthrough, is the same! Mine is an example of the struggle. I always work with at least a germ of an idea in mind and in this case my idea was to develop a new expression that would combine unusual shapes and my newly acquired fascination with the color yellow.

The breakthrough came with the fourteenth painting in a series, titled *Yellow Line*. *Implosion* is an example of the series I had been working on in which surface treatment is a large portion of the expression. My next seven paintings clearly showed my struggle and my progress; that is, the earlier pieces retain many of the elements of the previous series, and as I approached the breakthrough piece, *Yellow Line*, the shapes and the color yellow became dominant over the textural, vertical space—and I broke into a totally new expression!

Shortly after beginning work on *Yellow Line*, I knew that it would be the expression toward which I'd been working. From the beginning everything fell into place; it practically painted itself.

I am continuing my new "Yellow" series.

Louise Cadillac

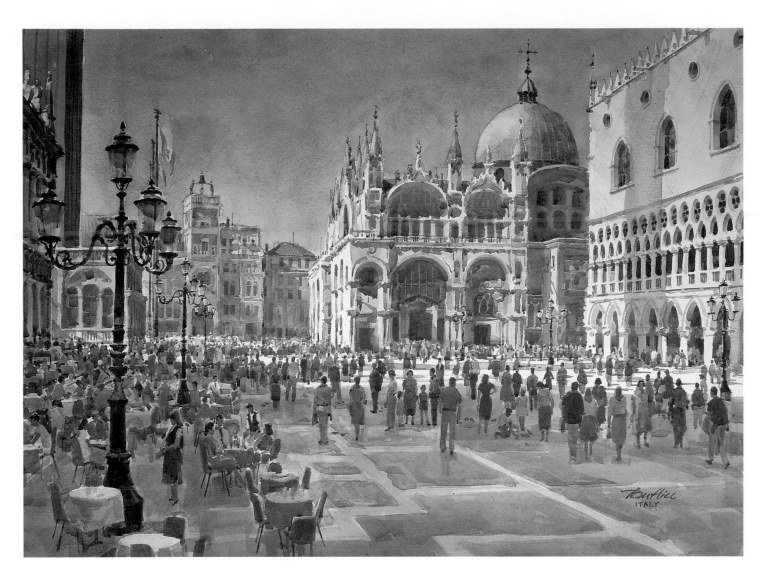

Piazza San Marco
21" x 28 ½"
Tom Hill

Traveling With a Lighter Load

I've painted watercolors since my teens. Still, every so often, new possibilities (which had been there all along) suddenly become apparent to me—breakthroughs, so to speak.

One of my more recent breakthroughs came about as a result of two things: painting on location while traveling abroad, and teaching watercolor to others. Painting on location with the use of a car or truck is one thing. Painting on location where you have to carry all your gear with you is quite another! After struggling enough times to get all that stuff to the actual painting spot, you begin to think of ways to lighten the load. A recent painting trip to Europe, where I had to travel lightly, helped to crystallize the realization that I really could carry a lot less painting gear—and still paint good watercolors. Previously, I used to take along as many as twenty different colors, dozens of brushes, even full sheets of watercolor paper!

Teaching students and encouraging them to find out how much could be achieved with only a few basic colors and brushes helped me focus on better solutions for traveling with a light load. The result of these realizations was a very satisfactory European painting trip with everything I needed fitted into a rather small bag that I could easily carry with one hand!

Tom Hill

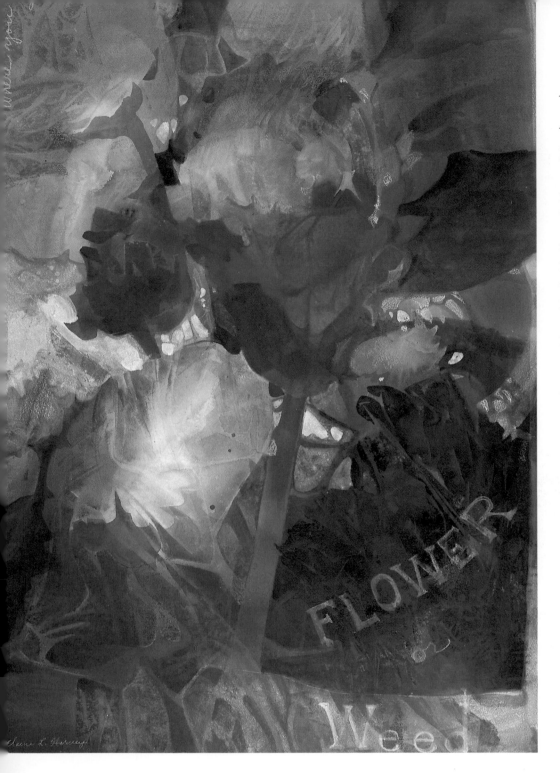

Finding Inspiration to Get Started

My most difficult painting problem has always been getting started. Once I begin I become lost in the process, ideas flow freely and so does the paint. But something—the possibility of failure, the preciousness of painting time, the cost of materials— makes it hard for me to begin a painting.

I tried location painting, simply painting what was in front of me, but the increasing complexity of my materials and techniques made this impractical, and it wasn't what I wanted to do anyway. I turned to the materials themselves for inspiration, throwing paint on the paper in a brave rush and then solving whatever problems I had created in the process, sometimes finding an idea that could be developed into a credible painting. I still do this to some extent and consider my interest in the subconscious mind to be an important part of my thinking, but I craved more conscious control and order than this process provided.

Therefore, I consider my most recent and useful technique for getting started a real breakthrough. I have begun examining my own work for recurrent themes and basing series of paintings on them. When a series is going, I am already "started." One painting leads to another naturally. When the series ends, I am still "started" because new ideas spring from former work. This process of examining my own work for inspiration came about rather by accident when I had to talk and write about my work. Forced to explain myself, I found something to explain, and the explanations led to discoveries that led to new work!

In *Upwardly Mobile Weeds* the recurring theme is: words as part of the design enhance the concept of the painting.

Upwardly Mobile Weeds
41" x 29"
Elaine L. Harvey

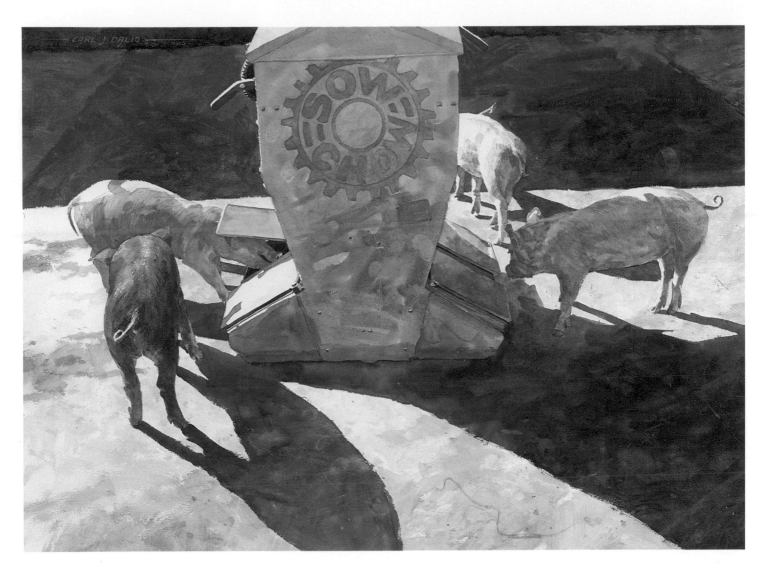

Family Pignic
21" x 29"
Carl J. Dalio

Let Your Subconscious Work on a Problem

Family Pignic is a specific example of a painting suddenly coming together after a long "creativity/incubation" time. I first saw these pigs on a farm near Denver and penciled this composition on a full sheet of watercolor paper. Due to what I felt was a potential problem in composition (feeder so broad and plain, daringly centered in the format), this simple drawing on watercolor paper remained untouched, stored for a few years.

As I moved on to other paintings, I feel my subconscious worked on this problem. One day the solution suddenly came to mind like a wave rolling onto shore! In a burst of total painting joy, I had the experience of being a thrilled participant/spectator as the watercolor seemingly painted itself.

By adding texture and glowing color, and with the addition of "Sow Chow" graphics, the feeder was able to act as a bridge to the similarly aligned but reversed pig to the right.

Through this creative experience, I am encouraged to seek new avenues to tough compositional problems. I have also become less patient with any tendency to hurry or force solutions to the painting process. I now know that careful nurturing of an idea from start to completion will allow time for the opening of doors to all-new adventures.

— CARL J DALIO — AWS

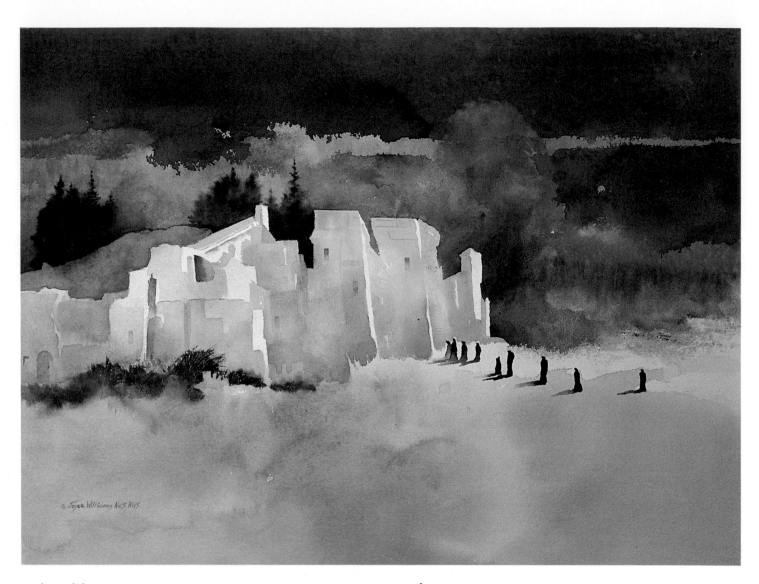

Seekers of the Shrine
22" x 30"
Joyce Williams

Put Your Painting Aside

Occasionally when I am about one-third through a painting, I become stuck, absolutely without knowledge of how to proceed from that point. If I feel that this work has real promise, I put it aside for a few days, weeks or months, almost forgetting about it.

When I bring the painting out and begin to study the pros and cons of it, a breakthrough comes, sometimes quickly, often more slowly, building up after a period of trying different solutions, using a piece of Plexiglas over the painting.

Strangely, the work often evolves into something entirely different from my first idea. This occurred with a recent painting of mine, *Seekers of the Shrine*. Begun as a moody rendition of an abandoned cement factory, nothing happened until a dark, dramatic sky was washed in behind the subject, bringing it into sharp focus and resulting in the transformation of a dull factory subject into an exciting, mysterious painting of the ruins of a castle or shrine with dark figures, needing only a few accents to bring it to conclusion.

Joyce Williams

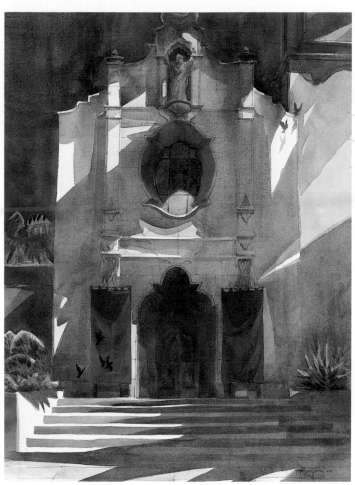

Bringing a "Failed" Watercolor Back to Life

I am sure that every artist has many breakthroughs, as many different ones as there are artists. After fifteen years of painting professionally and winning my share of awards and the like, I find I really don't know all that much about the true artistic process. I realize that I am just embarking on my journey. It's all very exciting and humbling.

A breakthrough that can be demonstrated is the process of continued work on a painting that I thought I had finished, or finding a way to utilize a painting that had failed miserably. *Easter* had hung in a gallery for months without receiving a second look. Finally, I took it out of the frame and applied a dark wash to three-quarters of the painting. In ten minutes what was a boring architectural study became a dramatic, powerful painting. It was the first piece to sell at my next show. I show the before and after slides in my workshops and they always elicit "ahs."

My work with gouache came about by trying to bring back to life "failed" watercolors. I will now purposely get myself "into trouble" just for the creative kick that I get. I suppose this wouldn't sit well with those who plan out their painting to the nth degree, but I find that approach boring.

MICHAEL SCHLICTING

Easter (before)
22" x 30"
Michael Schlicting

Easter (after)
22" x 30"
Michael Schlicting

Permian Basin, 30" x 40", Warren Taylor

The Crossroads of Life

In part two the focus is on external life events or circumstances. We can't ever know all that will occur in life, but we can choose to keep our eyes and hearts open and make the most of it. This section illustrates breakthroughs that stem from special teachers or from being a teacher, from a special or significant place, and from paintings or events that caused a boost in the artist's career.

Chapter four tells us that a breakthrough can come through one's students as readily as through a great teacher. Chapter five shows how looking for a home, moving to the Berkshires, living in Michigan's Upper Peninsula, or finding an old railroad yard can each be the catalyst for an artistic breakthrough. In chapter six we discover that becoming one's own boss, going full time, painting a scene you pass often, or even failing to be accepted into a show can lead to a major career boost. In other words, you can meet up with success at any juncture along the road of life.

4
Teachers and Teaching

Breakthroughs come only to those who are diligently practicing and stubbornly studying. The best effect of books, videos, teachers and the beholding of works of art is that they spur us on to self activity where sudden breakthroughs come.
—FRANK WEBB

Ed Whitney
22" x 15"
George W. Delaney

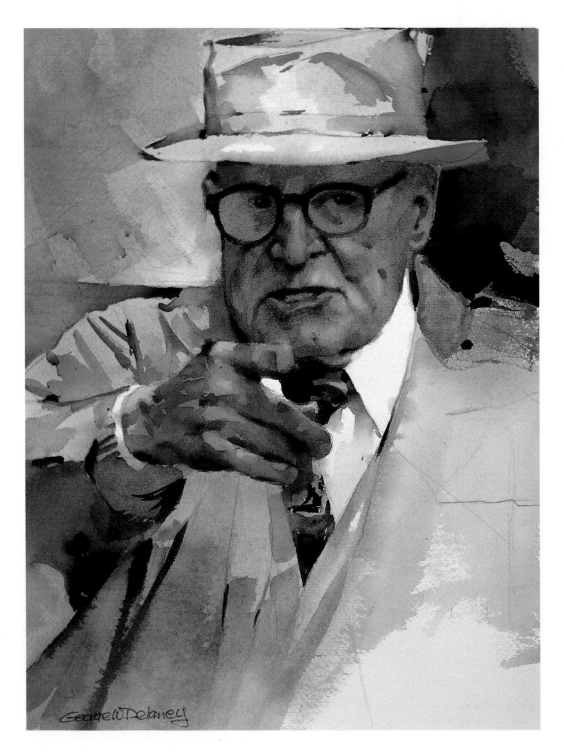

Joe
22" x 30"
George W. Delaney

Ed Whitney's Teaching

My biggest breakthrough came the day I walked into Ed Whitney's watercolor class.

To me, watercolor was intimidating. I soaked the paper, taped it on a board and made a careful pencil drawing. By the time I started to paint I was scared stiff.

Mr. Whitney gave me the knowledge and freedom to take a big brush and make big design shapes on a wet piece of paper. As long as this paper was wet I could add color, move it around, scrape it, scratch it, change it or even remove it. Watercolor was fun, it was quick. He taught me design laws so that I knew when it was right or wrong. No more artistic frustration; art is rational.

My art is basically realistic, but I always start with big design shapes and add as much detail and realism as necessary. At the left is a portrait I did for Mr. Whitney's ninetieth birthday. He loved it. It is his favorite design format, the "T"; and it passes the test of all his design laws.

Mr. Whitney died at ninety-six. He completely changed my views on watercolor. I, and many, many others loved him and will remember him always. All of my breakthroughs came and will come as a result of Mr. Whitney's teachings.

George W. Delaney AWS

Turn It Loose

My big breakthrough lately was gleaned from R.E. Wood, ANA, AWS (Green Valley Lake, California).

After many, many years of R.E. Wood trying to tell me to "turn it loose" and not rely on advance planning, I finally got up the courage to really do most of my work this way. I used to plan color schemes and have a value plan, and so on, and I would paint a good picture in spite of myself every now and then.

Now I trust the inner design sense and work from *memory*—after getting to know the character of the scene thoroughly (having fallen in love with it completely).

When I'm not looking at anything—it's just me and that piece of paper—I can feel all my design senses "perking" and "bubbling." I am letting the painting be an adventure; and as R.E. Wood would say, "Something special has a chance to happen!" He put it so beautifully when he described this type of endeavor: "A painting should be a winding path toward an unexpected goal."

"You have two experiences going on while you paint," said Cezanne, "the experience of nature [reflected light, subject matter, etc.] and the experience of the paper [colors and shapes that the artist enjoys and contrives]." R.E. has taught me to relate to the experience of the paper—because when I work from memory and it's just me and that piece of paper, that's all I have to relate to—it's that simple.

John Gaddis, AWS

Stillness
21" x 28"
Maxine Masterfield

Ideas Flow in My Classes

I teach experimental watercolor workshops in the U.S., Canada and Australia ten months of the year and have for the past ten years. Because of this, I have found a new strength in my work—a strength that might not have occurred if I had remained a solitary painter.

Because I have shared so many concepts, I am rewarded by those who share with me. Ideas flow in my classes and in my studio like an overfilled bucket of water. Before I began teaching, I used to stand in front of my easel for hours, wondering what to paint. Now there is no room for the easel. The walls and floors are crowded. Sharing with others is the key to creativity.

Masterfield

Bald Man
14" x 12"
Bill James

A Change of Surface

A few years ago I was looking for a more exciting and creative way to work with watercolor. I did many paintings using traditional techniques on stretched watercolor paper. Every piece seemed dull and lifeless to me. I wanted something more to happen in each painting.

Being an impressionist working with a loose, separated color technique in pastels, I wanted to somehow bring that into my watercolors.

I studied the work of Burt Silverman and David Levine and noticed that they worked on smoother surfaces. I decided to give that a try. I started coating my painting surfaces with gesso to give a smoother, nonporous surface. This caused the watercolor pigment to stay on the surface and not soak into the paper. I could now do a lot more with watercolor. I introduced more reflected colors

into the main color scheme, which blended together and created hard-edged circular patterns. Working with watercolor became more exciting.

The first painting I tried using this method was a piece called *Bald Man* (left). It was selected into the American Watercolor Society annual show and in two other shows, winning an award in one of them. Needless to say, I had found my technique.

The idea for *Turk's Cap* came simply from a gourd I saw at the supermarket. I loved its shape and color.

The Importance of Sensitivity

In the beginning of my art career I worked hard to copy nature. I developed a good technique in watercolor. I ended with a fair copy of what I saw and created pretty paintings of little distinction. I suppose I would have continued on as a passable watercolor artist if it were not for a man who imparted to me the importance of sensitivity in my paintings. His name—Louis Myljarack. He was not an artist of note, yet one of great influence to every student with whom he worked. His teachings and the study of men like Georges Braque changed me and I liked it.

Now I stylize and transform nature into art with all the sensitivity I have. The change was that simple and there was nothing mystical about it. This new way of thinking started in 1951. However, in that time of the postwar fifties, I chose the secure life commercial art would provide.

But I hung on to these ideals while working for thirty-one years in the commercial art world. Finally, in 1982 I turned back to watercolor and found that Mr. Myljarack's teaching was just as sound as ever.

DONOLD J. PHILLIPS A.W.S.

A Consideration of Visual Weight

Jars and Romes
14 ¹/₂" x 18 ⁵/₈"
Priscilla Taylor
Rosenberger

When I first started to paint in watercolor I turned from one subject matter to another trying to find one that felt natural to me. About ten years ago my first painting of glass jars deeply involved my attention and imagination. The experience led to white-on-white compositions, reflective surfaces and an intense interest in the effects of light. I began to manipulate lighting and study resulting colors, which I would then translate into transparent pigment, using neither white nor black. I found myself able to render convincingly in color what we usually think of as being without color, or clear.

I feel my work began to gain another dimension shortly after a conversation with Scott Noel, an artist and teacher. We had visited an exhibition of mine at a college gallery together and his comments were positive but he mentioned feeling the need for more weight, visual weight, in my work. He did not suggest just how to achieve it, but consideration of visual weight has enriched my work since then. My approach has been to consider relationships more keenly: formal, chromatic, textural, spatial. I try to make the object exist in, and possess, its space. It seems that I begin the painting by taking the objects of my composition apart, and then as I finish, I pull them together again. Finally in the finished work there is a simplicity in the forms at first glance, and an atmosphere around them. But on closer inspection, the wonderful patterns and colors caused by light are shared with the viewer.

Priscilla Taylor Rosenberger

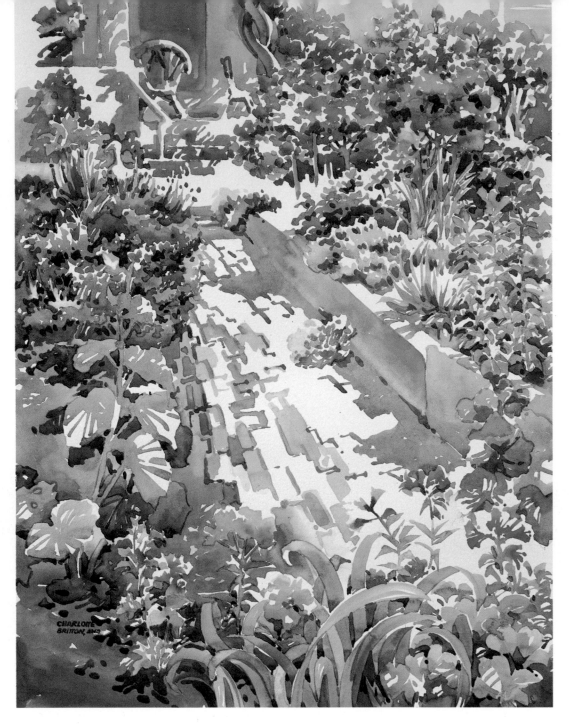

Garden Path
25" x 19"
Charlotte Britton

Keep Painting, the Breakthroughs Will Happen

My earliest teacher emphasized that painting was 10 percent inspiration and 90 percent perspiration—you have to really *work* at it. Paint all the time, not just a few hours once in a while or on vacation. If we do work hard enough and long enough and really want to do it, and perhaps also, if there is that certain something that might be called a spark of "talent," the flow really will happen. Suddenly, almost in spite of yourself, everything just goes *right!* Professional athletes talk about this kind of special moment or time when, after all the practice and learning, it all just feels right and works. Robert E. Wood once said something like, "I don't know what happened. I was just painting."

For myself, I am never sure about people who say that painting is good "therapy" for the stressed individual. For me the breakthroughs come with hard work. You keep painting, reading books, maybe going to a workshop, thinking about painting, trying new things to see if they work, and asking for advice. Frank Webb has been helpful to me in the past.

As Rex Brandt has said, "Get to know watercolor and it will show you a way." Keep painting; the breakthroughs will happen.

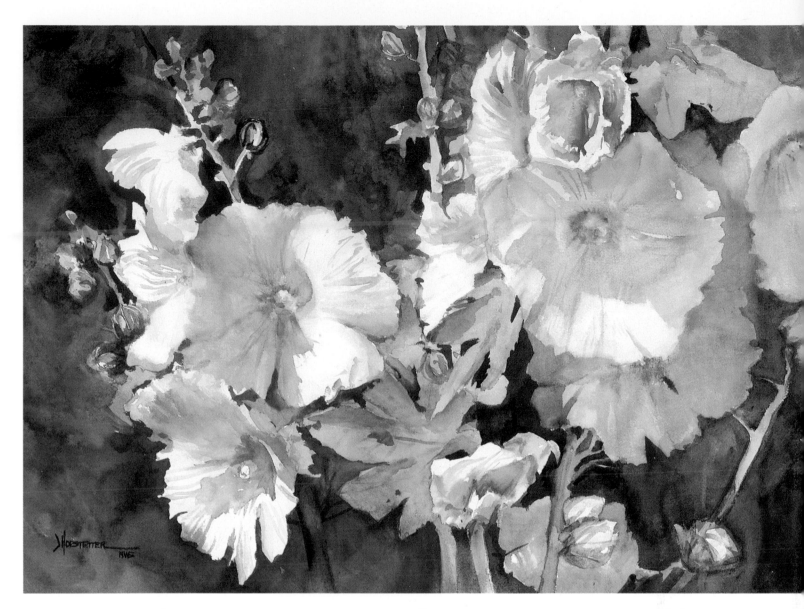

Unexpected Creativity From Teaching

Hollyhocks.
20 ¹/₂" x 28 ¹/₂"
Jane R. Hofstetter

Teaching watercolor painting regularly to more than a hundred advanced students is not easy. The demand to constantly search out new and interesting paths to follow in water media, so as to keep the classes growing and the students stretching their "artistic muscles," is darn tough. However, I have loved it dearly these twenty years because of what it has taught me.

The pressure and time element of the classroom has forced me to preplan and work rapidly through painting demonstrations. And yet, as organized as I try to be, often an unexpected insight or accident occurs that results in an even more expressive painting than I had planned. Such was the case with *Hollyhocks*. When I painted *Hollyhocks*, the lesson was on transposing a vertical subject into a horizontal or cantilever design. I had to cut up my photos of these tall vertical flowers and reposition them entirely. The unusual placement of the flowers invited me to explore color changes in a stronger way and give a whole new "look" to these familiar flowers. Thus, a classroom experiment became an unusual painting. *Hollyhocks* was finished just three months before this writing, and has already taken a "best of show" in an annual exhibit. This painting led me to transpose other expected shapes into their opposites for added interest, using many other types of subjects.

Jane Hofstetter N.W.S.
W/W

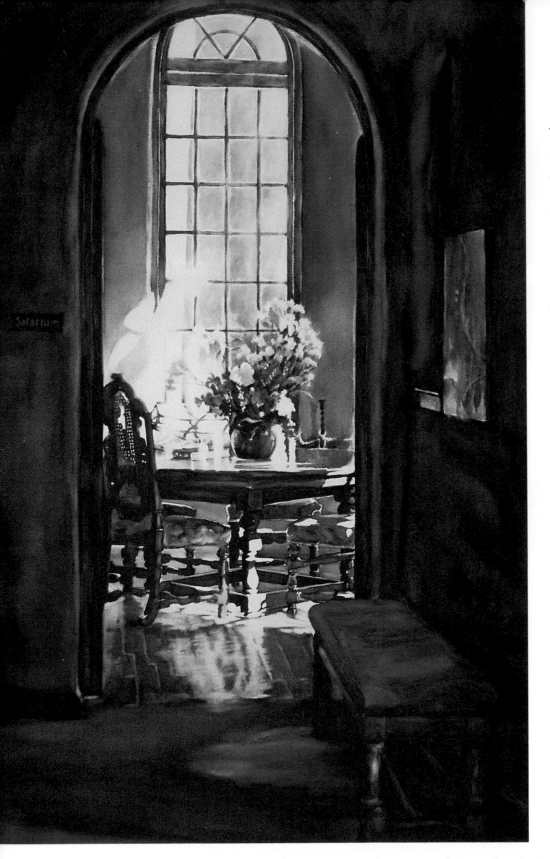

That Missing Ingredient

One breakthrough came in a watercolor class I took. During a critique, the instructor looked at my work and said, "Well, now that you know you can make a pretty painting, what are you going to say?" I had no idea what he was talking about. At that time I was struggling with the technical aspects of drawing and watercolor. My main concern was getting my subjects rendered correctly. But, once I heard his question and started finding my own answers, a whole new world of possibilities opened up to me. I asked myself, What can I say that only I can say? What do I see that only I can show? What do I feel that only I can express? I began to realize that a painting that offers only a description of what something looks like is missing something very important. That missing ingredient is the artist's passion, the reason he fell in love with his subject in the first place!

I decided that I would never again do an impersonal painting or just report the facts of my subject. I determined that the criterion for success would be whether the one quality that turned me on was apparent in the work, and not how real I was able to make my subject look.

I discovered my passion for painting interior scenes, a passion that continues today and I think is symbolic of my internal search for personal and artistic meaning and purpose. I believe that finding subjects I love and painting what I love about them, rather than just what they look like, made all the difference. It was a small shift in focus—from describing subject matter to saying something personal about it—but it was a real turning point for me.

While I was working on *The Solarium*, I wrote, "How to paint magic?" on the border of the painting. I was trying to paint the way I felt about a place that is very special to me.

The Solarium
34" x 23"
Donna Zagotta

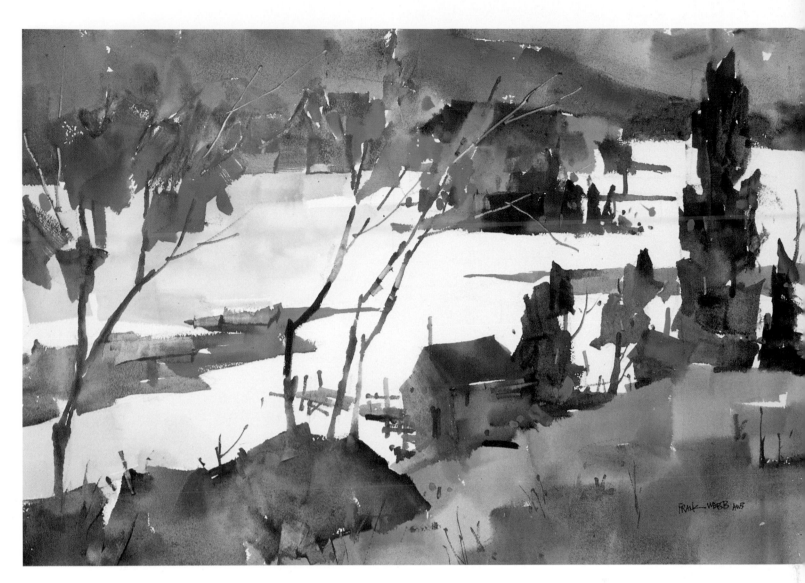

Mont Tremblant
15" x 22"
Frank Webb

Giving and Receiving With Enthusiasm

Early in my career I worked in two separate art worlds—fine arts and commercial art. My fine arts production was based on a life class habit of painting from observation. At the same time I used creative design principles in my commercial art practice. A breakthrough came in 1970 when I attended a workshop taught by Edgar A. Whitney. How clear it became: I must fuse my academic drawing procedure with design principles.

No longer was I thwarted by gray daylight, a bad station point, boring shapes and other limitations of the aspect of the moment. Now I began to make my own shapes, values, colors and sizes. I also found a way around the tyranny of linear perspective. I took charge! I combined re-created relationships with observed data.

Another breakthrough came with teaching. To teach well, it seems to me, I must sharpen my sense of art history, clarify aesthetic philosophy, become genuinely interested in others, enjoy making discriminations, sift possibilities and foster fellowships. This broader base of giving and receiving has imbued my life with quality and enthusiasm.

FRANK
WEBB AWS

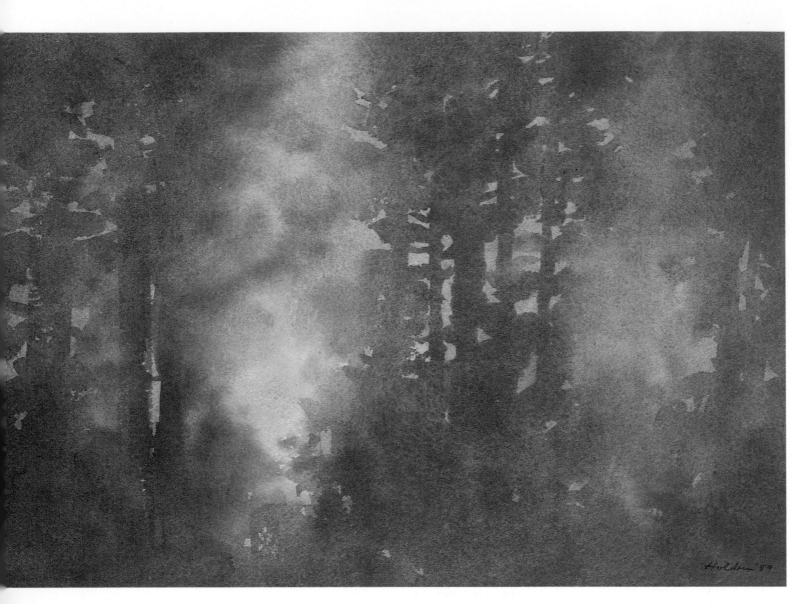

Forest Fire II
9" x 13"
Donald Holden

A Liberating Discovery From the Masters

Looking at the great masters of watercolor—Turner, Homer, Sargent, Wyeth—I made the liberating discovery that they have very little "technique." They work very simply, just brushing on the color, sometimes washing it off and trying again. No tricks. None of the special effects that make other artists exclaim, "How did he do that?" The great watercolorists are trying to say something, and they say it as simply as possible. Too much technique would just get in the way.

Because they're not fascinated by watercolor technique for its own sake, the masters happily ignore all the do's and don'ts—all the "rules."

Turner doesn't seem to know that a watercolor must be methodically planned before you touch brush to paper—because you can't correct or repaint a failure. He often lets the painting go its own way and surprise him. He doesn't hesitate to dunk the sheet in the bathtub, scrub it out and start again.

Homer and Wyeth seem to be unimpressed with all the warnings about muddy color. Homer's Adirondack landscapes are full of gorgeous "mud." And Wyeth often paints a whole picture with "mud."

Sargent may have heard that a "real watercolorist" doesn't rely on opaque color, but his landscapes and figures are full of opaque passages, and some strokes are as thick as oil paint.

All these discoveries encourage me to violate all the rules and do everything "wrong." I was taught to work from light to dark; I usually work from dark to light. I was taught to plan a painting with the greatest care; I never make a preliminary drawing on the sheet and I never know how a painting will turn out—so landscapes turn into seascapes, horizontal pictures become vertical

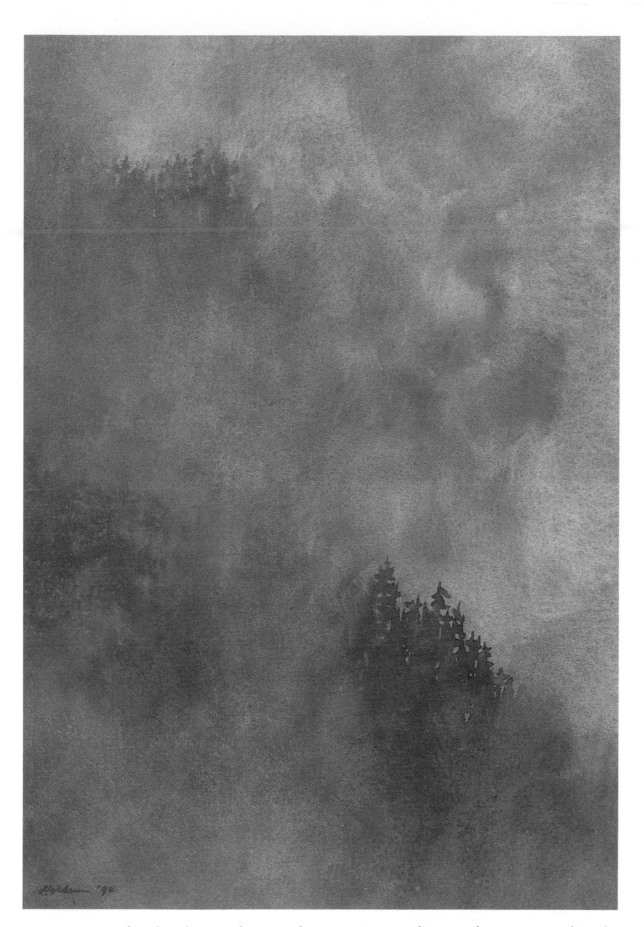

compositions, and sunlit subjects end up as night scenes. I was taught to avoid corrections and watch out for "mud;" but I work and rework a watercolor until the paper won't take any more punishment— and I like the smoky neutrals and mysterious darks that watercolorists call "mud!"

These two paintings are from my "Yellowstone Fire" series.

Holden

5
Places

Breakthroughs come from conversations with friends, through reading, travel, found objects. Breakthroughs are everywhere and come when least expected. They are what make painting wonderful—the hope that the next painting will be the best.

—PAT DEWS

Gothic Revival
11" x 9"
Elizabeth A. Yarosz

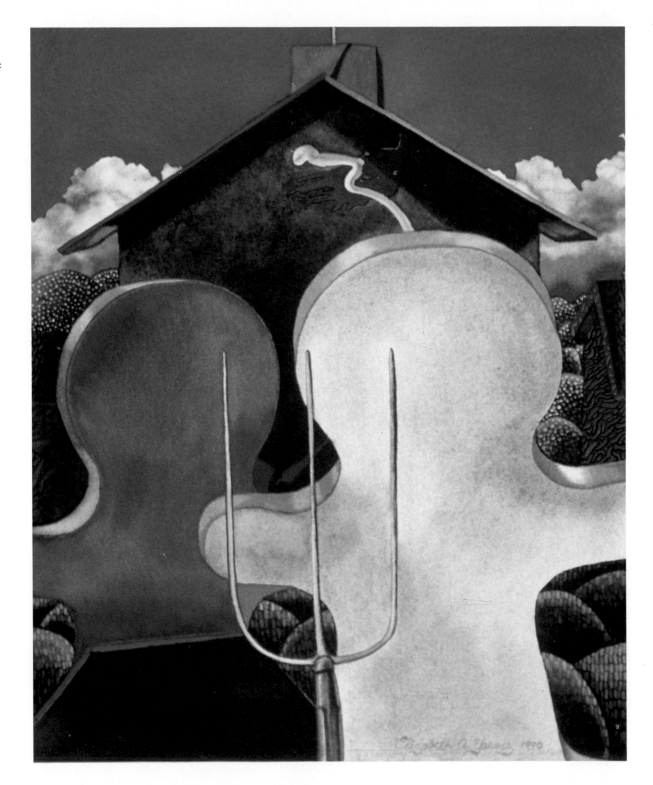

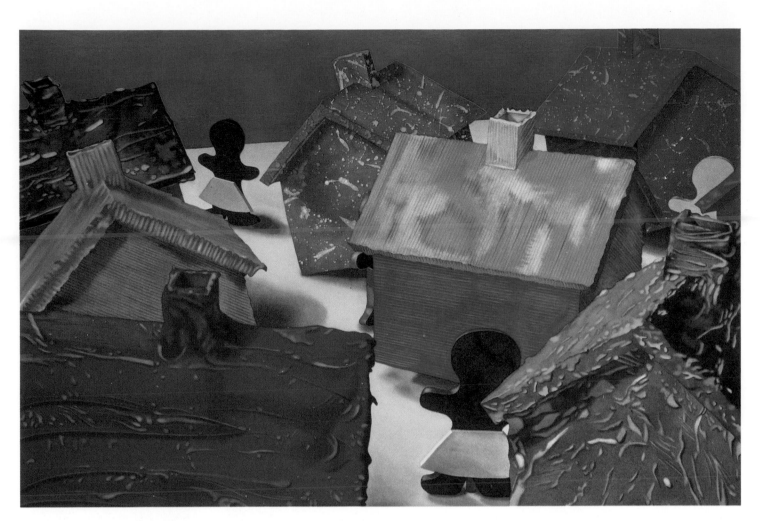

In Search of the Perfect Dwelling

*In Search of the
Perfect Dwelling*
40" x 60"
Elizabeth A. Yarosz

My most significant breakthrough occurred in 1985 with the painting, *In Search of the Perfect Dwelling*. My husband (also an artist) and I were looking for another house that would be large enough to include studio and office spaces. During the search, I was making 4"x 6" textured house constructions out of a foamcore board and acrylic. I decided to use these houses as a personal metaphor and portray them in my paintings. I immediately went on to construct tiny "cutout" figures (both male and female) to interact with the houses in various situations. This painting was the first result of this process. We eventually purchased the house next door to us and converted it to our studio and office spaces. So we now live in two houses. I even have a modest-sized vegetable and flower garden in the backyard.

My paintings became an outgrowth of "making a home." The narratives address the mental and emotional states of mind one encounters in such an adventure. Houses as subject matter appear frequently. My relationship with my husband and other friends is pictorially explored throughout this ongoing "life event." Although these narratives are based on real experiences, they are whimsical and invented. At times the paintings become quite absurd and humorous, as does life itself.

I've recently completed a series of ten watercolors, of which *Gothic Revival* (left) is one, that appropriate from paintings of art historical merit and interact in a playful dialogue with the houses and figures. They contain references to the integrity of works of art on paper, illusion, the paradox of the human condition, personal relationships, an appreciation of art history, and a love of watercolor painting.

Elizabeth A. Yarosz

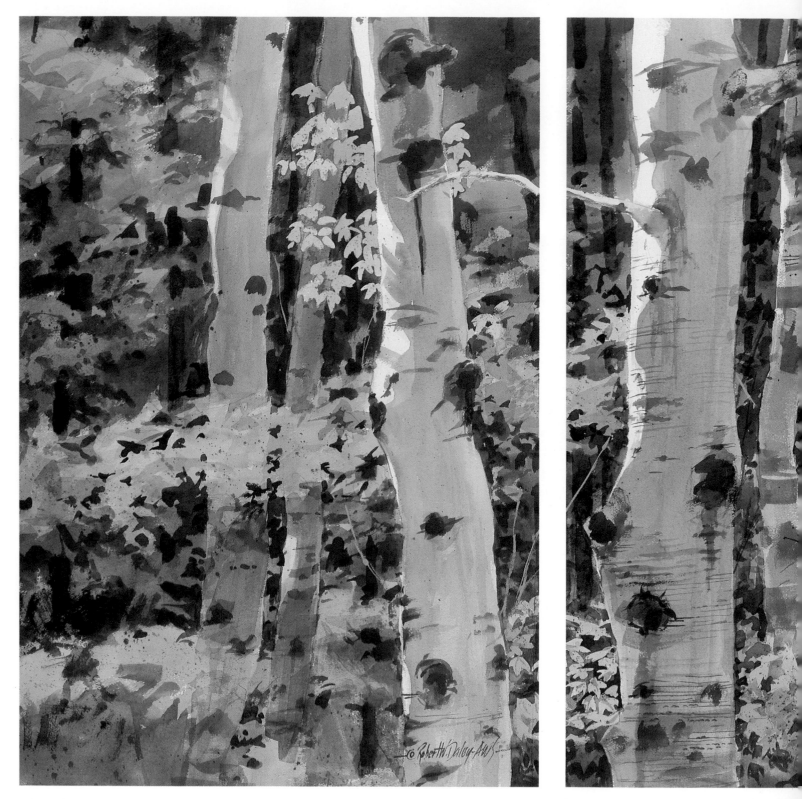

The Path From Here to There (triptych)
30" x 66"
Robert W. Daley

A Move to the Berkshires

The almost imperceptible but growing realization of the importance of light on a subject was a breakthrough for me. I think it all started, really, in a drawing class conducted by Edward Kaminsky while I was still in art school in Los Angeles. Those simple studies of light and shadow on basic forms carried through the years into oil painting, creating stage scenery, doing many murals and decorative treatments in buildings, and finally to watercolor painting.

I have painted in many locations throughout the world, but when I moved to the Berkshire

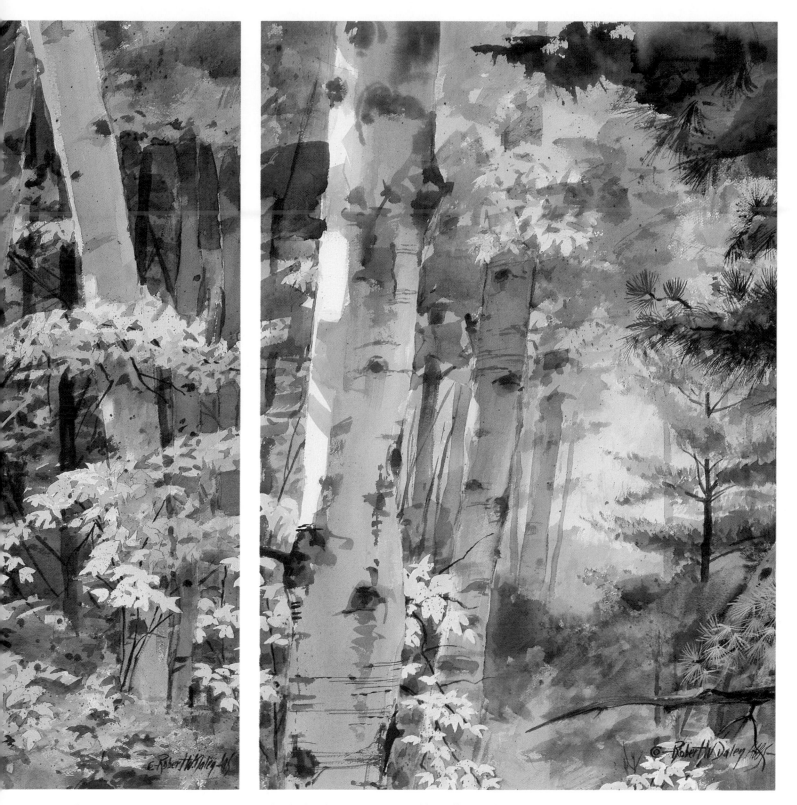

Hills in 1965, I became aware that the light there was noticeably different from any other area in which I had worked. Soon I realized that a new and exciting dimension had been added to my work, a breakthrough that had been growing through the years. The dappled light on the birch trees, as seen in *The Path From Here to There*, has become my favorite subject for outdoor work.

Robert W. Daley AWS

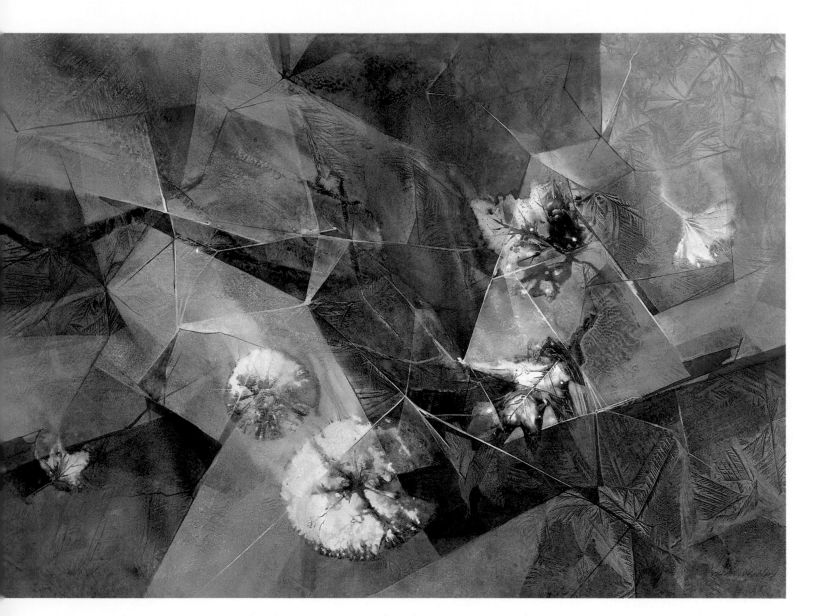

Frozen Night Pond
22" x 30"
Kathleen Conover
Miller

Let Nature Work for You

Letting nature paint for me instead of painting nature has been my breakthrough. My natural environment (Michigan's Upper Peninsula) includes six months of winter, but painting winter scenes in the studio became boring. Now I look forward to my favorite ten- to twenty-degree clear winter days because painting with naturally formed crystals has been my latest inspiration. When conditions are right, I put pigment and water on paper outside and let nature work for me by freezing the pigment and catching those elusive, fragile ice crystals. Then my work begins. Taking what nature has given me, using the crystal elements, I design and develop my paintings to completion.

I have always been intrigued by the natural forces, physical actions and chemical interactions at play in mixed water media paintings. Using crystals painted by nature is my most recent interpretation of the relationship of these natural components to art.

My current focus is to look creatively at what occurs in nature and relate this directly to my work. Six months of winter could be considered an obstacle to painting from Earth's inspiration. I now use this environmental extreme to my benefit.

Kathleen Conover Miller

Ramblings Through a Forest Wonderland

*Environs of
Pamajera #136*
29" x 40"
Alex McKibbin

Pamajera is a sixty-acre tract of land that is traversed by a narrow creek called Chase's Run. This area
has been both a sanctuary and an inspiration for me for well over a decade. My children first
introduced me to Pamajera; it had been their playground for several years before I ever laid eyes on it.
Actually, it was my alarm at their references to a creek that first got me over there. What has
converted this locale into a "special place" for me has been the process of experiencing it deeply,
claiming it by feeling—the building up of a certain reverential awareness through the many years of
contact. This has all been heightened by its very fragility in the much-dreaded march of progress—
my depictions of it increasingly feel like acts of salvage in a desperate time.

My ramblings through this forest wonderland eventually summoned up an extended series of
sites, some of which immediately struck me as infinitely paintable. Others were passed by season after
season until, as if magically, they leaped out at me as having tremendous possibilities. Coveted sites
will often, through age or surprises of weather, be dashed—their principal players carried downstream
or left to rot away where they were felled. The cycle of the seasons, the life cycle of the flora as well as
that of the creek bed itself, has provided infinite variety for me—older trees succumb to be replaced
by willowy subtile saplings. I am in awe as I watch the sycamores cling so tenaciously to the
embankments along the creek bed. I study the rocks as they bear witness to the force of the creek.
The trill of a bird, the babble of the water, all of the sounds remind me to maintain a sense of
rhythm, movement, urgency—destination.

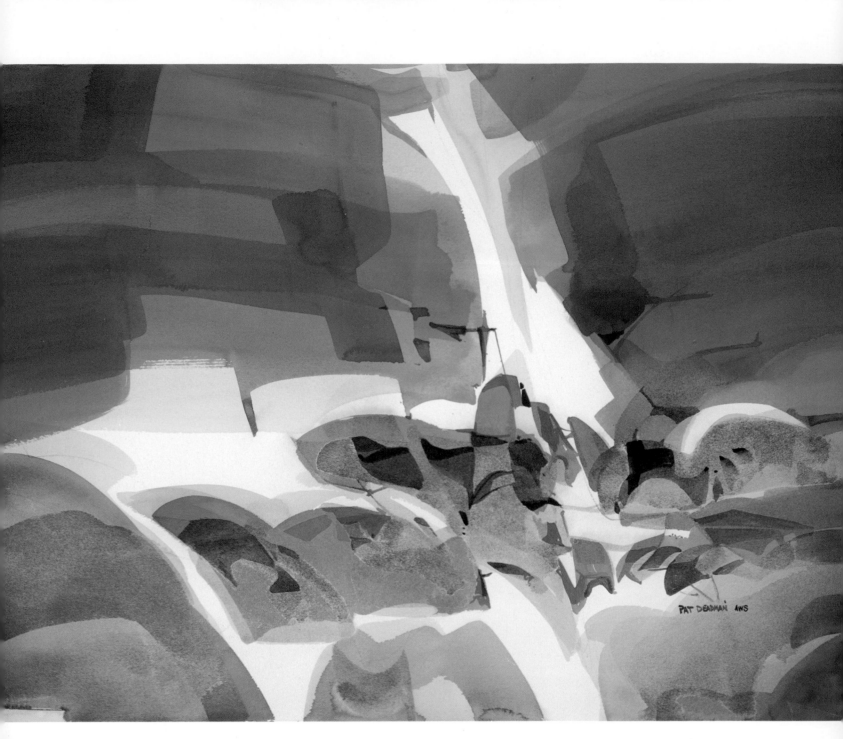

Santa Elena
22" x 30"
Pat Deadman

Photograph of Santa Elena

The Power of the Place

When in the presence of the beauty and power of nature, I was inspired and compelled to convey what I experienced. The place, Big Bend National Park, was unlike anything I had ever seen or felt. This situation called for a different manner of thinking and reacting for a painter. This stretching of the mind and imagination to express a place leads to breakthroughs.

In the presence of 1,600-foot canyon walls, I felt that grayed color did not do justice to the spectacular canyon. Therefore, I enhanced and altered the color to try to equal and illustrate my emotion and wonder.

Pat Deadman AWS/NWS

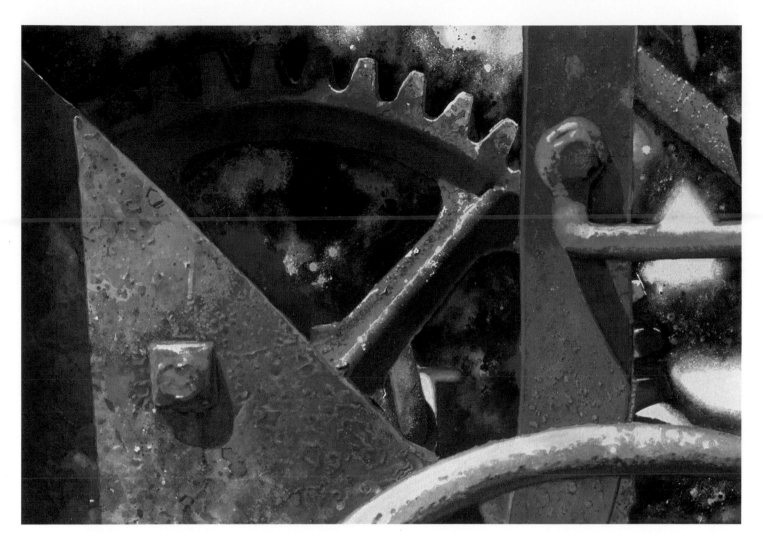

A Strange Avenue in a Railroad Yard

Arrested
Obsolescence
29" x 41"
Alexander J.
Guthrie

My coming show was to be on railroads, not a particularly original theme considering the burgeoning interest in steam locomotives and railroad memorabilia in general. I scoured the country in search of a new motif.

It was a searing hot day, hot enough to cause one to hallucinate. I was walking down a strange avenue in a railroad yard, all kinds of cars and rolling stock on both sides—a narrow street—a magic street—a street that one might encounter in a dream. I walked the length twice and was amazed at the abundance of themes and patterns available. There were all kinds of strange devices, almost abstract in quality, with unimaginable textures, all conditions of lettering, marvelous cast shadows—a diversity of materials and runic devices, marked by the hand of man, whose meaning has long been forgotten.

Best of all, they all contained the moribund qualities that I enjoy painting. They are all crumbling to dust or at least in a state of "arrested decay." Many of them are awaiting the hand of the skilled artisan to restore them to their original splendor. I prefer them the way they are.

Texture has form, and I attempt to paint it that way. I can imagine strange shapes, fantastic animals, languid nudes, demons, gnarled hands, old-fashioned shoes, machine parts—invent them, tie them together and let the texture come alive. I don't rely on exotic methods or aberrant materials. Paint gives me variety enough.

This was a revelation! My next show shall be an expansion of this concept. One or two paintings will be similar but, I hope, better in structure and impact.

This "magic street" gave me fuel for my breakthrough, and for me now is "the only way to go."

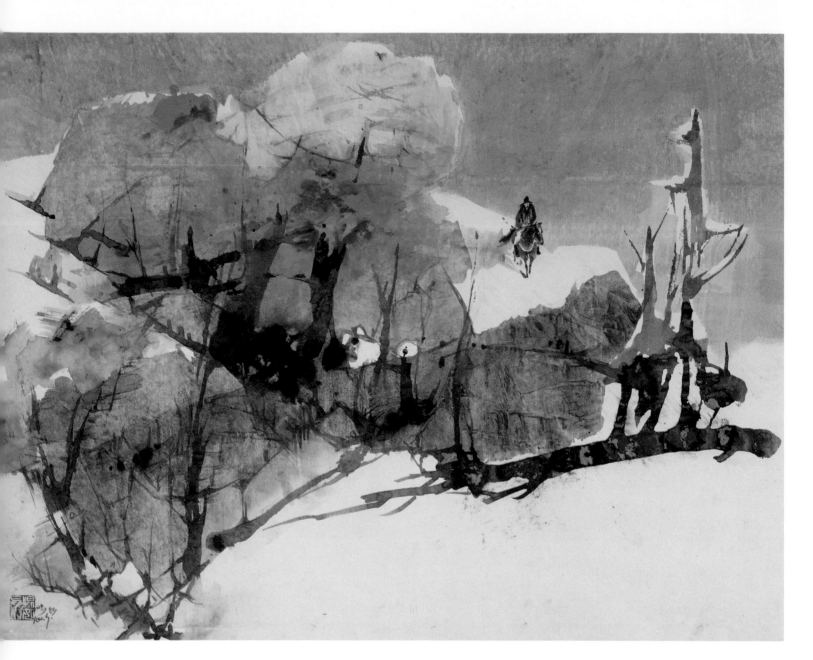

Snow Rider
25" x 33"
Kwan Y. Jung

Influenced by Two Localities

I was trained in traditional Chinese watercolor painting. I then later studied, and also taught, a more experimental Western approach, but I have remained a direct brush painter all along.

My personal breakthrough, which influences the way I paint now, has evolved through my efforts to combine the tradition of the place of my birth with the new techniques and freedom I learned here in the United States. I try to bring together the Oriental formulations and the exuberant color and non-objective forms of contemporary American work. *Snow Rider* is watercolor on rice paper in a more traditional sumi-e style. But I am also experimenting with new forms. Generally, I start by flooding watercolor on my paper in pleasing forms. When these mobile shapes suggest a recognizable subject, I allow the color to dry. Then, using my brush like a pen, I draw enough detail to clearly suggest the subject I have in mind. Lately I've been using acrylics because the color holds better in the washes. I am currently experimenting with iridescent acrylics used as watercolor.

Forced to Paint at Home

Composition VII
40" x 60"
Electra Stamelos

Sometimes when life hands you the worst blows you will find (in retrospect) that it was a time of epiphany. When I first started my career, I painted out of doors. But when my mother (who lived with me) became ill with cancer and I became her full-time nurse, I had to discontinue going out, so my painting "place" became my home. I found I was also too tired to set up interesting still lifes or stretch paper as I was used to.

I started using 300-lb. paper on watercolor blocks, working from photographs. There was no time or energy to sketch or play around with compositions in my sketchbook. Yet I was still frustrated because I found others' photographs lacking the kind of information I needed—something I had not been aware of up to that point. This forced me to renew the use of my camera, which I had used extensively in graduate school. My photography improved and I realized that what interested me was light and a variety of shapes—both positive and negative space.

Being forced to accept the limitations of being at home caused me to be more creative. My "Composition" series is a result of this exploration of shapes.

Electra Stamelos

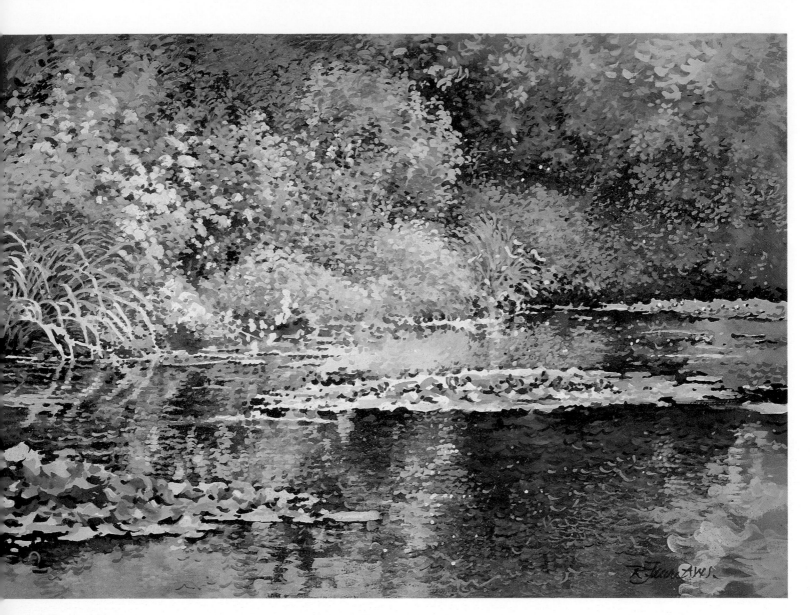

*Le Jardin aux
Nénuphars*
29" x 41"
Renée Faure

A Trip to Explore My Heritage

While I have always supported myself and my family on the income from my artwork, it was not until recent years that the dominant portion of that income began to come from the sale of my watercolor paintings.

This happy circumstance began to evolve after a trip to France with my mother in 1983. It was a trip to explore our heritage—my mother was born in Giverny while her father was painting there under the influence of Monet.

We spent three weeks in the area while I painted small sketches of the little town, of the Monet gardens, and of the surrounding landscape. I returned home with twenty sketches and hundreds of slides and decided to mount a solo exhibition entirely on this one theme.

This first show (May, 1984) enjoyed such an enthusiastic reception that I have since made three more journeys to ever new magical areas of France and mounted two more solo exhibitions. The most recent, in May, 1991, sold out (thirty paintings) within the first week!

I believe these paintings touch the spirit in others because I felt such an affinity for the place myself.

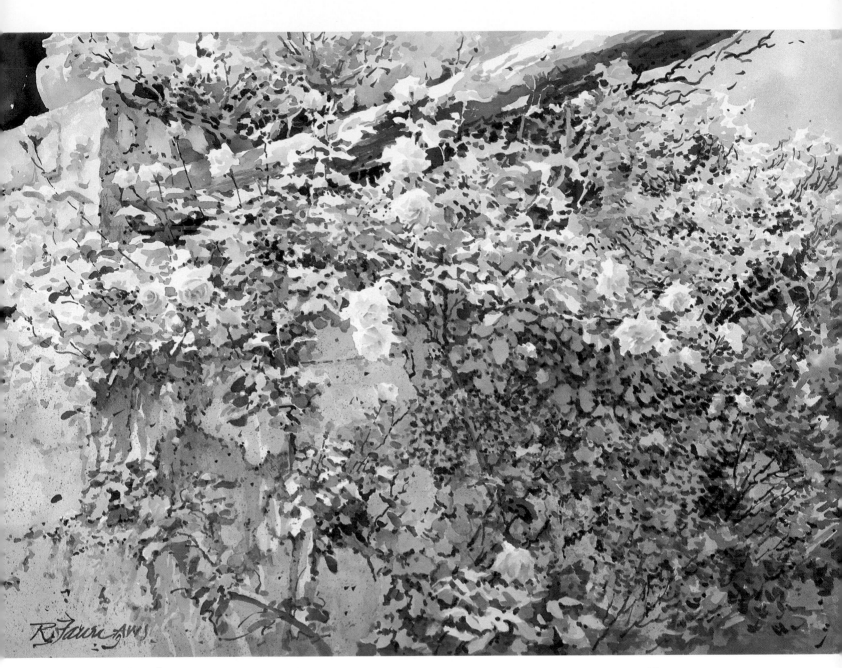

Les Roses de la Mediterranée, 29" x 41", Renée Faure

6
Career Boost

Breakthrough: An important mental departure to new creative expression.
—EDWARD MINCHIN

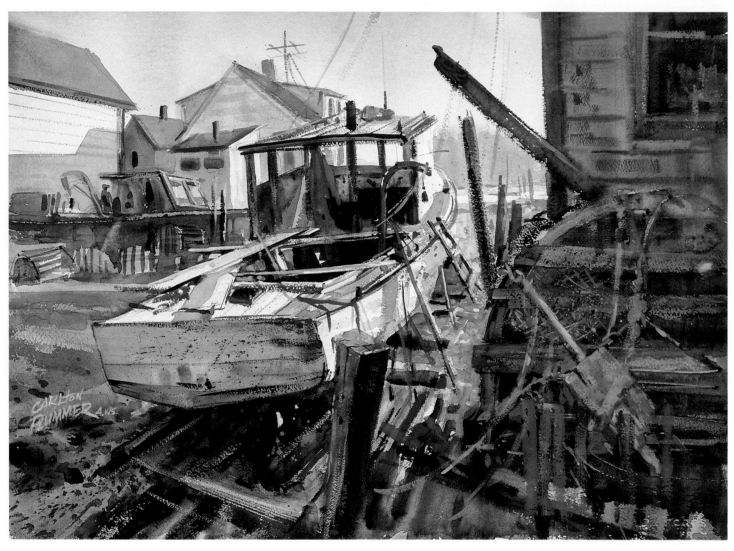

Port Clyde Sundown, 21" x 29", Carlton Plummer

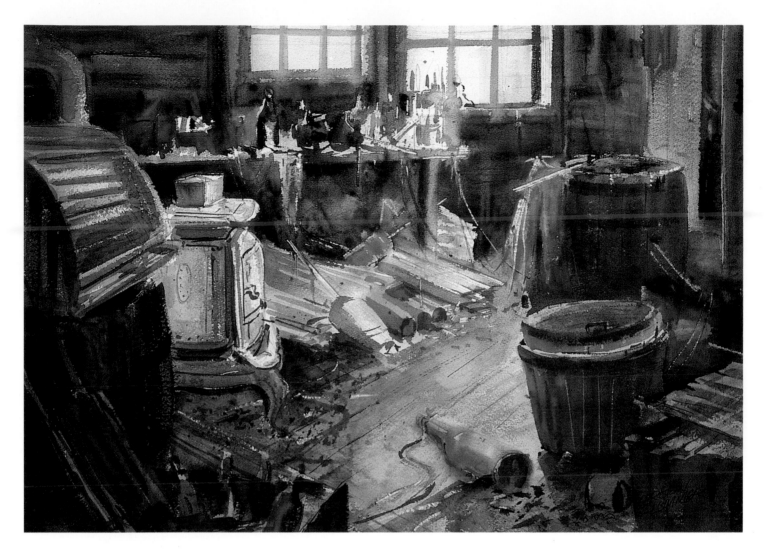

A Change of Viewpoint

A significant breakthrough in my early painting career came as a result of exploring old lobster shed interiors along the Maine coast (see *Lobsterman's Retreat*, above). I had been struggling with achieving real unity in my landscape paintings and I sought out an altogether different subject matter. Painting the fisherman's gear in low lighting and limited space constituted a major change from executing watercolors of coastal ledges in open sunlight and unlimited space. However, this proved to be the catalyst to an important breakthrough.

After several interior paintings, I became more aware of the wide range of interrelated values within the larger value shapes that formed the overall structure of the design. It became obvious to me that this was the missing ingredient in my land- and seascapes.

This important visual element is seen in *Lobsterman's Retreat* as the strong contrast of light and dark forms a focal area. It is the subtle mid- and low-key interrelated values that create the cohesive structure needed to make the painting read as a consistent whole.

In *Port Clyde Sundown* I made use of what I'd learned about values in those old lobster sheds and it won eight national awards for me.

*Lobsterman's
Retreat
21" x 29"
Carlton Plummer*

CARLTON
PLUMMER AWS.

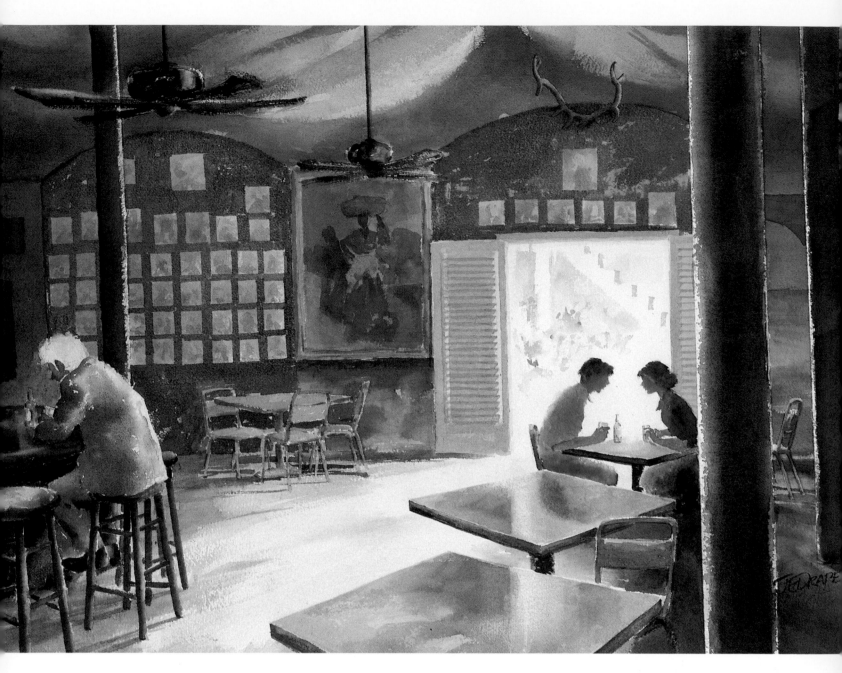

Sloppy Joe's,
Key West
21" x 29"
J. Everett Draper

Spare-Time Watercolorist to Full-Time Artist

In my case the nearest thing to a breakthrough occurred when I decided to "break out" of the large corporation where I had worked for many years as an artist and art director. From the art standpoint, the work had ceased to provide satisfaction.

I was able to go from being a spare-time watercolorist to a full-time artist, fortunately, with immediate success. The ensuing freedom enabled me to paint on my own schedule without deadline pressure, which made a great difference in how my paintings developed. Previously I never had the option of setting work aside for an idea or concept to incubate. This, plus the time to travel and teach, provided constant inspiration and a never-ending supply of subject matter.

J. Everett Draper

Grief and Failure Turned Into Breakthroughs

I painted *Spindrift II* in the weeks just after my brother-in-law died. It was an emotional time for me and I turned for comfort to what I do and know best—painting. This painting was a breakthrough in the sense that it was a better painting than any I had previously done. It's almost as if it painted itself, or as if God were directing the brush. This painting became a new standard for me to gauge my work by—as if I had made a leap to a level of excellence I really hadn't attained before. I still feel this is the best painting I've ever done.

Another breakthrough occurred this year when I was eligible to become a member of the American Watercolor Society (AWS). At first I became "paralyzed." I had many wonderful painting starts that I just couldn't seem to finish. In the end I painted two under pressure; they were certainly not my best, and I was not accepted. The problem was that my work habits were not as disciplined as they needed to be. I was indeed devastated and vowed to change. I cleaned my studio and even reorganized my files. I took a course on how to be organized and practiced what I learned. Now I know what I'm going to work on each morning—I leave it on my board the night before. I finally feel like I have some control. I realize and accept that I like to have many paintings in progress, but I am now finishing a group before plunging ahead.

It will never happen again that I don't have paintings ready ahead of time. You cannot paint for shows. I knew that before, but I had bad work habits. However, I took failure and turned it into a breakthrough.

Pat Dews

Introduce a New Element

My "Vine Essence" series paintings began an extraordinary breakthrough in my career. They immediately received awards in major national exhibitions. They were inspired by nature close-ups that I love, but were made much more contemporary by the introduction of a new element—geometry. My work is textural, organic; adding geometrics helped to organize it. Within the vertical bands, I freely explore my visions.

Yesterday's Treasures was another breakthrough—one that resulted in my "Treasures" series—a juxtaposition of occasionally outrageous objects. This allows me to add humor and mystery to my work. For *Yesterday's Treasures* I must have drawn on my childhood days... being dragged through one antique shop after another by my mother.

J. Van Dyke, NWS

Yesterday's Treasures, 30" x 22", Jane Van Dyke

Salt Water Asters
31 ½" x 23"
Neil H. Adamson

River Mist
16 ½" x 33"
Neil H. Adamson

I'm My Own Boss

Salt Water Asters was a big turning point in my career. First it was picked by AWS for their traveling show (1975). A gallery in Connecticut saw it and started to show my work. Then an art publisher in New York saw my work at the gallery. He contacted me, came to Florida, and picked six paintings to publish. I found that adding wildlife to my work (as in *River Mist*) generated even more interest. I had a three-year contract with them. I saw what the publisher made at the end of three years and decided to publish my own work. I now have thirty-six different images in print; twelve are sold out. I have my own corporation. Boy, can things change. I love it, and I'm my own boss.

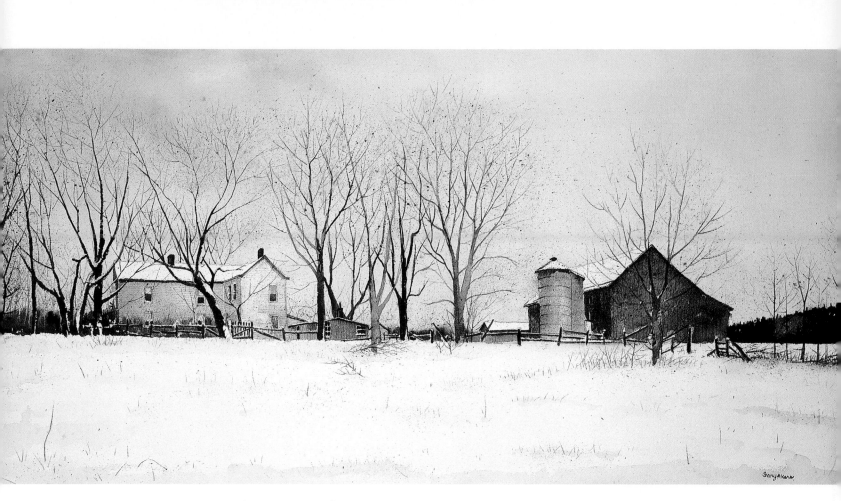

A Scene I Had Passed Many Times

Winter's Grays
18" x 36"
Gary Akers

Winter's Grays marked a crossroad in my career. It was, at the time, the largest painting I had ever done, and the first watercolor I ever entered into a national show. It was accepted into the Kentucky Watercolor Society's "Aqueous '78" exhibition and won an award. In 1979, it was accepted into the Southern and American Watercolor Society shows.

It was released as a limited edition print, which sold out quickly. Because of this watercolor, I was commissioned to paint the other three seasons of this scene. Now this collector has purchased a large number of my watercolor and egg tempera paintings.

I had already painted the scene in *Winter's Grays* many times in my mind as often as I had passed it. I finally did it in about two hours using a black-and-white Polaroid photo for reference.

Gary Akers

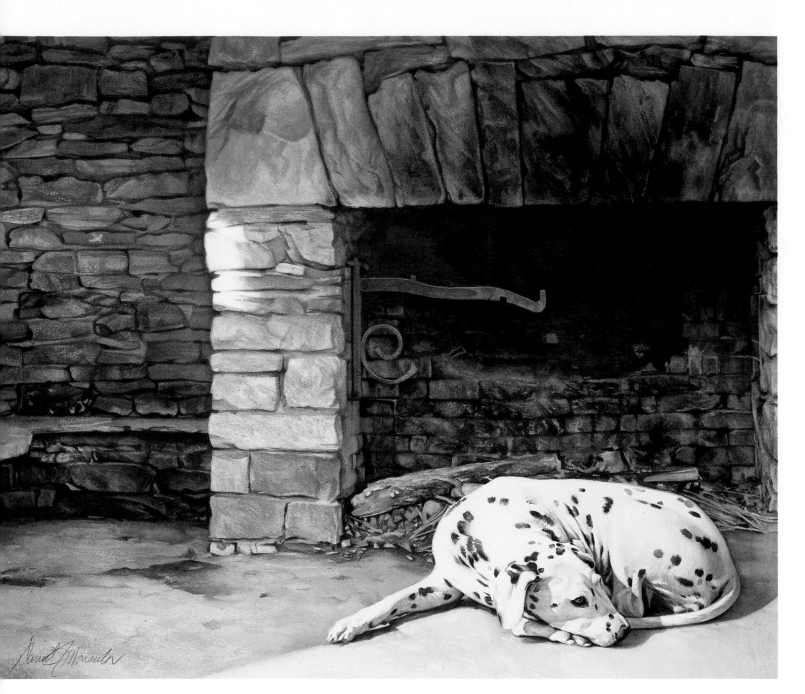

At Rest
15 ¹/₂" x 19 ¹/₂"
Daniel J. Marsula

Inspiration From Three Outstanding Role Models

The ultimate goal of any artist is to find a look that not only arouses his own creative juices, but also captures the interest of the viewer. Recently, my work has brought me much attention due to my renewed inspiration, which can be attributed to three outstanding role models: John Singer Sargent, N.C. Wyeth and William Merritt Chase. Their influence helped reorganize my creative thinking process regarding mood, technique and strong attention to composition.

I am currently concentrating on creating art with texture, rich color and a simple but strong composition. In the piece *At Rest*, sunlight comes through an unseen window, bathing a stone hearth in a warm, relaxing glow that is inviting to the eye. This formula, which I have used in my past few pieces, seems to work well.

I try to convey a peacefulness in my paintings that will relax the viewer. In a painting of my daughter, *Lisa*, the positioning of her arms roped around her legs conveys a certain quietness, still within the same composition formula.

Due to my newfound inspiration, my work has gained me signature membership in the American Watercolor Society and the Midwest Watercolor Society, as well as showings in numerous

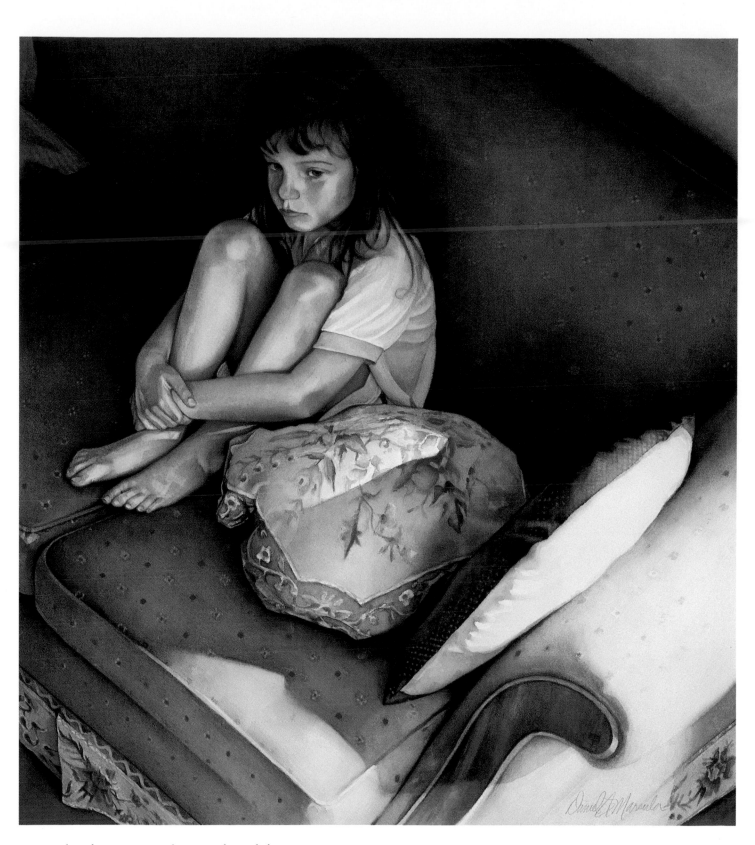

national and international watercolor exhibitions.

I feel that an artist never stops growing creatively. My philosophy is that one must always be ready for inspirations, which only comes from hard work. One must be on hand to ride the wave of inspiration to wherever it may lead.

Daniel Marsula

Lisa
16 3/4" x 15 1/2"
Daniel J. Marsula

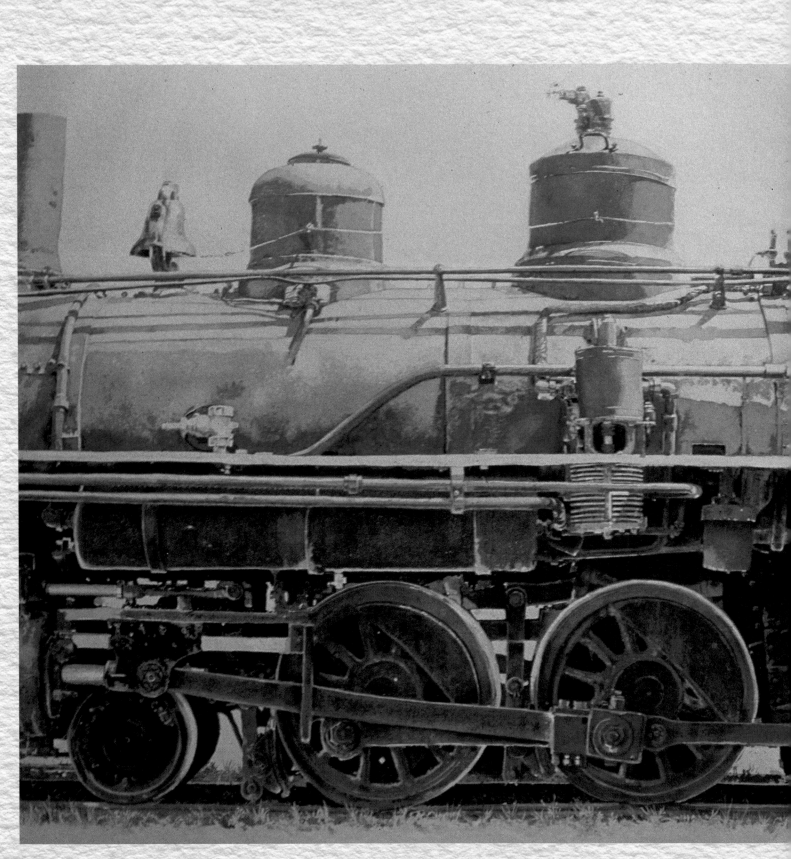

Slim Princess, 35" x 55 ¾", Alexander J. Guthrie

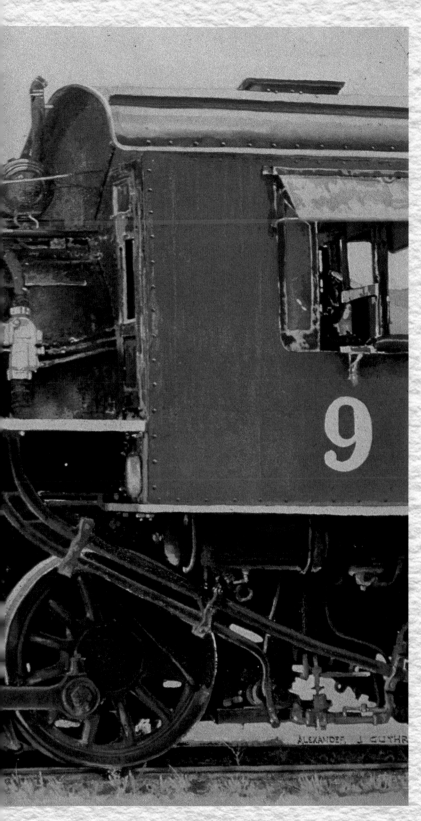

The Great Discovery

Part one highlights intentional changes in the artist's craft, and part two talks mainly of how outside events can influence the artist's life and work. Part three turns inward and looks at the breakthroughs that can come from new attitudes and new directions. This section celebrates the power of the inner spirit to effect change.

Chapter seven tells how being open to life's little accidents can offer the artist unbidden new potential. You will read how the accidental placement of a fish on a dock led to a new direction and a series of paintings. You will see how admiration for the Old Masters inspired a unique and ongoing series of still-life paintings. Other chapters tell how nurturing the inner self, developing a habit of perseverance, and simply realizing the fact that "Artist is my job" were all part of artistic breakthroughs. These artists have learned that you can't always wait for the breeze; sometimes you just have to flap your own wings.

7
Happy Accident

Breakthrough: The act of discovery through the juxtaposition or association of different objects seen in a new relationship.

—Paul St. Denis

Kaleidoscope
30" x 22"
Al Brouillette

Bird of Paradise Trio
22" x 27"
Al Brouillette

I Was Surprised and a Little Upset

The evolution of my painting style seemed as gradual as the transformation of a sand dune grazed by a breeze, but during October of 1984 an incident occurred that suddenly altered the shape and content of my work.

Up until that time, my paintings were based on nature in all of its themes: water, leaves, rocks, snow, branches, etc. As I was photographing an arrangement of leaves, my film ran out. I reloaded my camera with what I thought was a new roll of film, but it wasn't. It had been partially exposed previously when I had been shooting some geometric shapes. For some reason that I can't remember, I'd removed the film from the camera and promptly forgotten about it.

After completing my photo session with the leaves, I mailed the film to the developer. When it was returned, I was surprised and a little upset by what had happened. Some of the slides had double images of a geometric pattern overlaying an arrangement of leaves. When the initial shock wore off, I realized I was looking at something I'd never seen before, and it excited me so much that I painted my impression of it.

First experiences seem to be remembered more vividly than those that follow, and that's the way it is with *Kaleidoscope*, my first double-vision painting. The fact that it was awarded a gold medal of honor is merely icing on the cake.

Al Brouillette

The Mat Board Scraps Dropped

Working with new techniques is exciting and inspirational, and yet at the same time it can create anxiety for the artist. Achieving the desired results in an innovative and creative manner without becoming reminiscent of others using the same techniques is always a concern. That was the case for me at the completion of a workshop in "Experimental Watermedia Techniques" with Maxine Masterfield.

As I began to incorporate these new techniques into my work, I found that months of work and stacks of paper discards became the norm. In my quest to master these techniques, I filled a spray bottle with white ink and began recoating the work that I had discarded. While recoating these pieces, I dropped several scraps of mat board on the surface and began spraying before I realized that they were there. When I discovered the shapes on my paper, I knew instantly that by carefully planning the placement of these masked areas, exciting compositions could be achieved.

Manipulating the surface with intricate overlays of color and texture, and developing new images utilizing these techniques, has led to the evolution of a series of serious works that have been most rewarding. The series has continued to grow and the prospect of working these images further is truly exciting.

Mary Ann Beckwith

I Placed My Palette Next to the Fish

After cleaning a salmon I had just caught, I decided to do a watercolor painting of the filleted fish with its bright red-orange sides, head and tail still attached. I placed my palette on the dock next to the filleted fish and proceeded to do a watercolor study of the fish from an oblique angle. After the watercolor study was completed, I noticed on the dock the interesting relationship between the rectangular palette of bright colors and the fish shape with corresponding hues. This gave impetus to a series of palette-fish paintings with the fish and palette parallel to the picture plane for a more formal and abstract arrangement—a more unusual concept than the straight traditional pictorial point of view. I would not have conceived of this composition or concept had it not been for the chance placement of the palette and fish.

Paul St Denis AWS/NWS

Weathered Vane
22" x 30"
Joyce Williams

I Looked Up to See the Perfect Design

Seeking unusual subjects for painting, I wandered past an antique shop window. Out of the corner of my eye I saw a large fish shape turned upside down: a fish weather vane. Here was an exciting subject!

After haggling with the shop owner for a while, I rushed back to my studio with my purchase and strove in vain to come up with a strong design sketch. As I agonized over it, I looked up to see that the moving sun had given me the perfect design by casting strong vertical shadows on the wall behind the vane; the vane proved to be the strong horizontal line to make a good design. The resulting painting, *Weathered Vane*, won an award in AWS.

Joyce Williams

Vreedenhoop
30" x 40"
Jorge Bowen Forbes

When an Unsuccessful Exercise Was Immersed in Water

The series of watercolors that includes *Vreedenhoop* was indeed a breakthrough. This all came about by pure chance when an unsuccessful exercise was immersed in water and a bristle brush was dragged randomly on the painted surface to lift off as much color as possible.

My good fortune was being experienced enough to see, and to take advantage of, the possibilities that suggested themselves as the colors rose up and blended to create an altogether abstract feature. When this was dried, the work was then allowed to evolve slowly through emphasis and de-emphasis of color and shapes.

The figures are always added as a "finisher" to strengthen the design, with reciprocal lighting and lost-and-found edges staging the mood for eye and mind participation.

The breakthrough was primarily a moving away from starting with a preconceived idea.

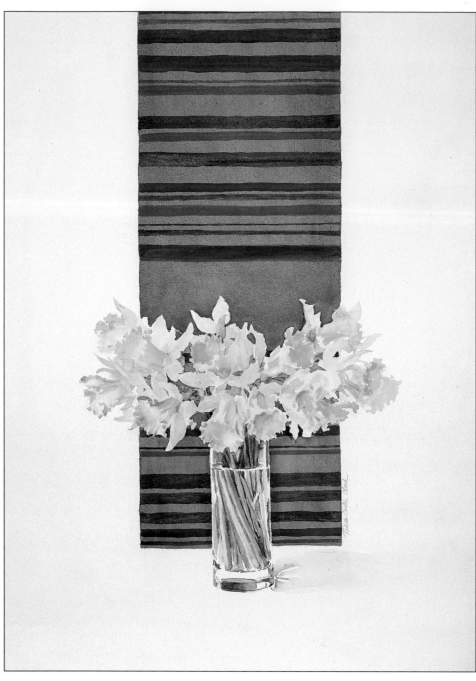

Painting While Recuperating

A few years ago, a large, heavy oil-on-Masonite painting slipped out of my hands and fell on my right foot. In February of 1990 I had to have an operation to correct the damage incurred by a bone broken at the time. The doctor prescribed eight weeks of no standing, no walking, no driving and no stair climbing. My home is a condominium on the second floor. I had to cancel all obligations and commitments and, after the first few painful days passed, I had to think of how I would use all those precious days at home.

I've painted for many years in oil and watercolor, always standing at an easel with much walking back and forth, but standing on either foot produced such throbbing and swelling as to prove the doctor right—it hurt too much and it would never heal if I didn't get off it.

I devised a way of sitting on a chair at the easel with the leg stretched out straight on a second chair and the watercolor palette on a stool in front of me. Not being able to move around forced me into painting in a more studied way, using what was around me for subject matter.

Daffodils With Blue
30" x 22"
Roberta Carter Clark

A friend brought me daffodils from the supermarket. They were all one length and I would have cut some of the stems to make the little bouquet more varied and interesting under normal circumstances. Then I noticed the yellow blossoms formed this odd horizontal shape when I plopped the flowers into a glass vase, and I decided to see what I could do with them. With the blue silk scarf hung behind the bouquet, this static painting turned out to be one of my strongest images ever. This gave me the impetus to do more in the same vein. It was a real luxury to have all that time to use any way I pleased and to just let these strong paintings come out.

Roberta Carter Clark

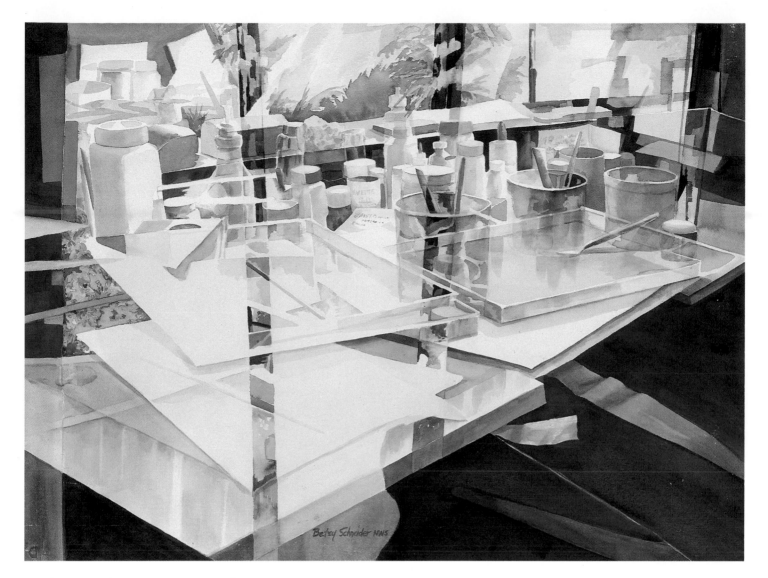

The Film Jammed

I am well acquainted with the feeling of working and struggling for years without much success. *Live Oak* is representative of my former style of painting. My breakthrough began as an accident. Working with a new camera in my studio, the film jammed, causing double exposures on the entire role. I saw palettes, brushes and tubes of paint floating about, and a watercolor I was working on at the time became suspended in the air over a wall! The shapes fascinated and excited me. Instead of throwing away the photos, I kept them and used them as the basis for my "Double Exposure" series. The first in the series was accepted in Watercolor West and National Watercolor Society with an award.

The series influenced future work also. I began to "see" Realism differently. I enjoyed and was fascinated with the process of fracturing the realistic rendering of rocks, flowers, landscapes and buildings with geometric forms or whatever shape would abstract the picture plane and make it visually more exciting.

Betsy Schneider NWS

Double Exposure #13
22" x 30"
Betsy Schneider

Live Oak
Betsy Schneider

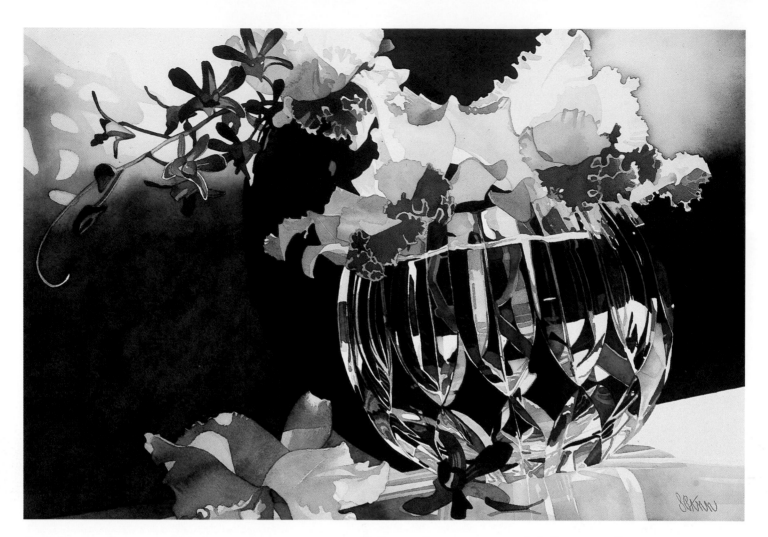

*Remembrances and
Regrets*
30" x 40"
Susanna Spann

I Was Mesmerized by the Incredible Light

My personal breakthrough came when a friend of a friend called me to come to her exquisite home and design a commission piece. Upon entering the house, I was mesmerized by the incredible light that permeated the rooms and especially how it came through her small crystal art objects. At this time I was painting tropical foliage from my yard in Florida with its graphically designed shadows and subtle variations of color.

When I do commission pieces, I try hard to make the paintings personal, relating the mood of the home and the personalities that live there. After getting a feel for the home, I wanted to incorporate crystal, black, mauve and various textures in a tropical setting. Quickly I sketched an idea that had a tall, black laquered vase, a mauve sea urchin, and a crystal bowl filled with a spray of orchids projecting a shadow on a wall. When this was accepted, I set out on my adventure to locate the objects, set up a still life, and photograph it. The black vase I retrieved from my daughter; the urchin I had hidden in a box of "sea treasures" in my studio. It was then a matter of finding the perfect crystal bowl!

That weekend I was excitedly talking to another friend, Janette, about the idea when she smugly pulled out of her dining room the most beautiful crystal bowl that I had ever seen. It was a Swedish Orrefors given to her by her mother-in-law. I ran home, shot film, designed the watercolor and began painting like a mad woman!

The overwhelming response that I received from this first watercolor of the "Janette's Vase" series was so encouraging that I have continued with it for the last two years. There are now about thirty paintings in the series from 15" x 30" to 40" x 60". This personal breakthrough pushed me further into thinking abstractly, yet designing photo-realistically.

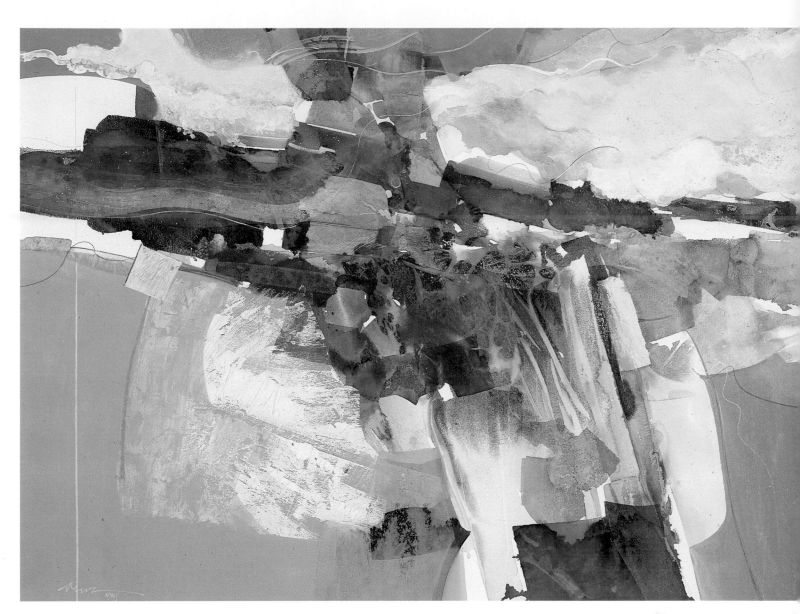

Water's Edge
29" x 40"
Pat Dews

An Unusual Tool

My most recent breakthrough came when I was giving a demo. I was demonstrating a certain technique when I realized I had forgotten my brayer. I grabbed a 32-oz. jar of Liquitex matte medium instead, thinking it would be flat like a rolling pin. I didn't realize there was a raised rim on the bottom portion.

I had a very wet area that I had just painted with a mixture of acrylic paint and gesso, and I wanted to put uncrumpled waxed paper over it, rub it in and let it stand. It gives a great textural effect even uncrumpled. What I didn't expect were the deep impressions the rim made in the wet surface of my smooth paper (BFK Rives). The indents looked great and were freely and randomly drawn—the look would not have been the same if I had studied where they should be. It was easy to then see that I could incorporate this with pencil work. I told those watching that this was a breakthrough. The most important thing to remember is that breakthroughs *happen in the course of working and can't be forced.* When something like this happens, you then know how to use it next time.

Pat Dews

8
New Directions

Breakthroughs happen because they are the harvest of long, hard searches. So they will continue as long as the journey lasts.

—WARREN TAYLOR

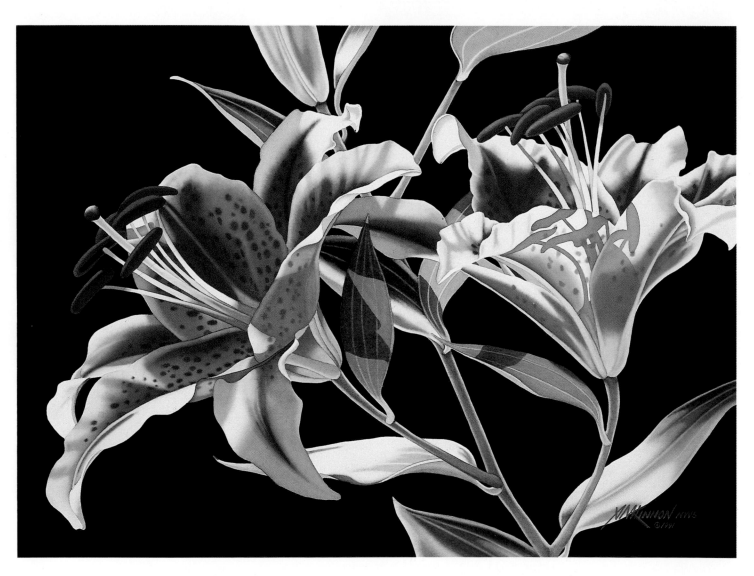

Stars and Stripes, 21¹/₂" x 29", Susan McKinnon Rasmussen

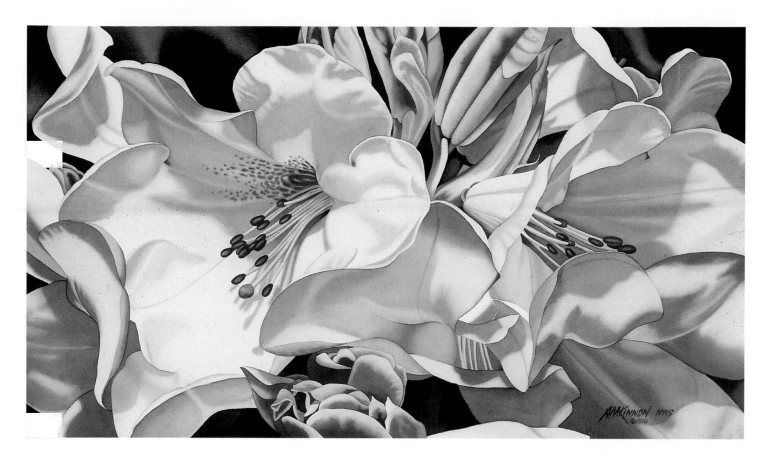

An Intimate Perspective

Spring Fanfare
23¹/₂" x 40"
Susan McKinnon
Rasmussen

In the more than twenty years I have been painting in watercolor, I have had several breakthroughs. The one that significantly changed my work and gave me a recognizable style came when I stopped trying to paint the "scenic postcard" view. Instead, I narrowed my field of vision, bringing my viewer into a close-up, intimate perspective. All of a sudden, my work took on a much more dynamic look. I was able to exaggerate values, play up light and shadows, and work with larger shapes and brushes.

My earlier work tended to place the viewer as a bystander, back from the scene and not at all involved. Flowers, too, were often painted as a vignette or with a feeling of botanical illustration. Now I concentrate on a portion of a boat, versus several boats in the harbor, as before. I will paint a few rocks instead of the entire stream, riverbank and background trees. Now floral images always extend beyond the borders of the paper, indicating a very select view of just one, or a few blooms. Some pieces bring the viewer so close up that the painting has almost an abstract quality. I want my viewer to be totally immersed in the middle of the flowers or so up front and personal it's hard to avoid the impact of the painting.

In thinking back on how I came up with this approach, all I can remember is when playing with strips of paper trying to crop my photo for a good composition, the smaller and smaller I made the image, the fewer items I included and the more I liked it. I could concentrate on light and dark patterns and actual shapes; instead of painting a scene, I was now creating a design. I often will develop a full-sheet painting from just a 1-inch square of my reference photo. This intimate viewpoint approach to my subject was a breakthrough that made a significant difference in my work.

McKinnon

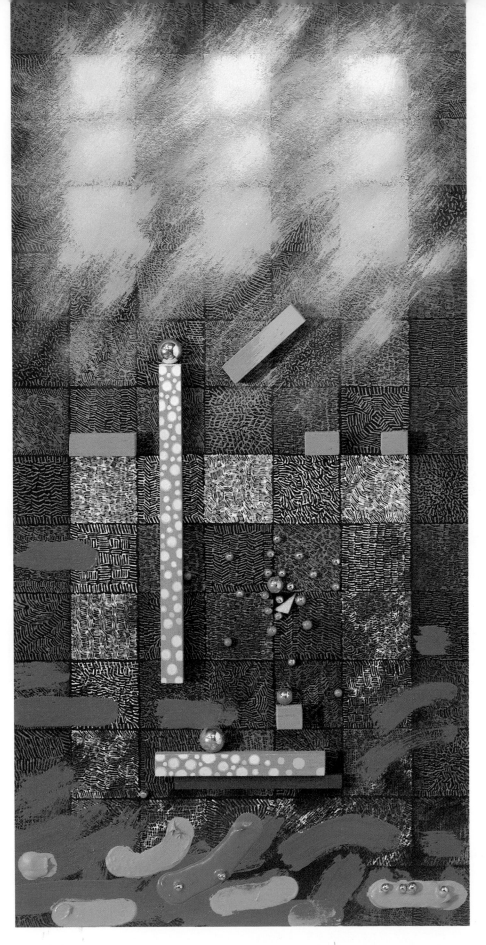

Realism Was Becoming a Burden

Can you imagine what it was like to change from a photo-realistic painting style (as seen in *Splash 1*) to an abstract one? For me, it was a breakthrough.

My new artworks are a combination of acrylic paint on top of an etching of a textural grid with various items glued to the painting's surface. Originally my thought was to change from painting to printmaking, and I began by working on a number of small etchings. However, when I executed the textural grid plate, the multiple possibilities jumped off the plate at me. What I had here was a foundation for numerous artworks without having to make more plates. The idea of using this single design as a surface upon which to paint various unrelated designs was enthralling!

The more I painted and composed, the more possibilities I saw. I was quickly realizing that I was still a "painter" at heart as I continued to invest more and more time in the painting of each image.

The realistic works had become more and more of a burden to produce. Since I worked from photos (even though they were my own), replicating these images somehow just did not fit my personality. From start to finish I always knew what the final product would look like. With these new works, practically every stroke is an experiment and a step into the vast World of What If?

Early on, I realized these works might prove more interesting if some sort of 3-D item was attached to them. The first things I used were the gold beads (as in *Special Places*). In the beginning I didn't attempt to depict "light" as a subject as in these paintings. Earlier I saw light as coming from within the picture, integrated into the grid. I then started to represent light coming from the outside by brushing paint across the paper.

Special Places
14" x 7"
Stephen De Santo

Steve De Santo

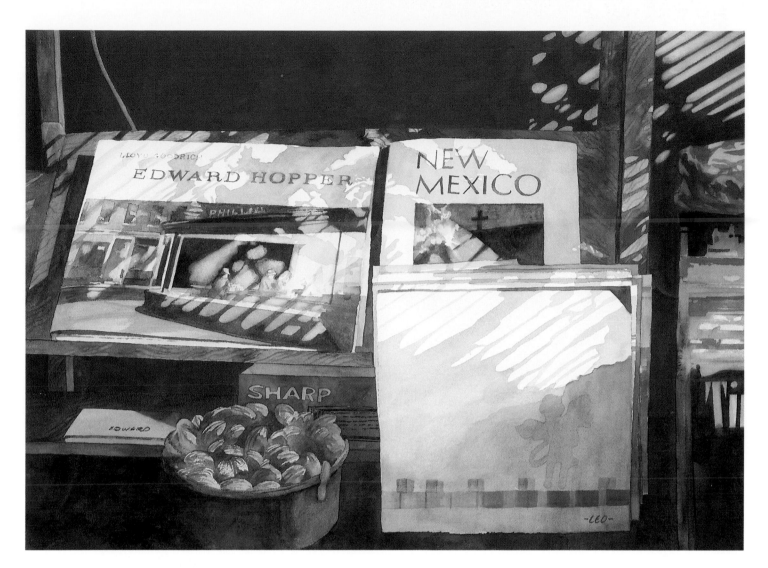

Afternoon
22" x 30"
Leo Smith

A Visual Image Stopped Me in My Tracks

A number of years ago I was walking through my house when I saw before me a scene of light and shadow that stopped me in my tracks. What was before me was a visual image that would have a great impact on my work. I could hardly wait to make the painting. I wanted to share with others something that I had found very special—something that had been there all the time, but I had not seen it. The painting *Afternoon* was the result. A noted artist told me that she thought the painting was significant because I "had taken the ordinary and elevated it to art."

The impact of this experience on my work is very evident. I have taken the time to examine more closely things in my own environment and the environments into which I travel.

Looking back, I know the exact moment that the most important paintings I have done first occurred to me. I know when the concept or visual image came to me. It may have taken several months for the painting or paintings to be completed, but I knew at that moment they would be made.

-LEO-
AWS

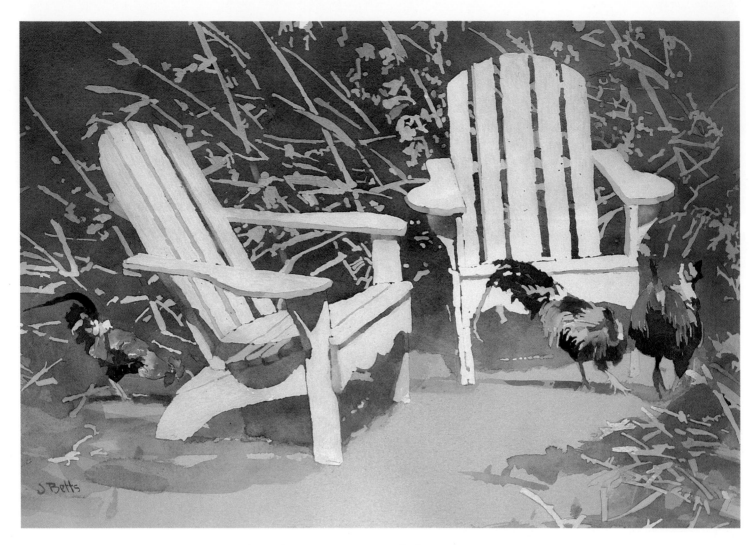

Patio Party
22" x 30"
Judi Betts

"Magical Shapes" Add Mystery to Paintings

A breakthrough for me was learning to see the shapes of my world as flat areas. Then the exciting part of that discovery was that I could draw the shapes that I saw. These are not "thing" shapes—such as a tree, a vehicle or an animal—they are usually patterns of light against a midtone or darker value.

One day Rex Brandt said to me, "Where do you get your 'magical shapes'?" and I said, "I see them." I see thousands of them each day. Some are edited—I exaggerate what I see or I leave some out of my composition—or I may turn the shape to help serve as a visual arrow in my painting. Often I combine several small shapes to make a more interesting pattern.

For me, "magical shapes" are the highlighted shapes in masses of foliage, the sky holes in tree forms, and splashes of light dancing on flat, grassy areas.

I use magical shapes to help direct the viewer's eye, to add a visual vibration to the surface of my paintings, to create intrigue and to orchestrate color throughout a painting.

I transform reality—chicken feathers, holes in a wicker rocker, buds and blossoms in a garden, insects and birds, fences—into my own magical shapes.

Some magical shapes are part of the early planning stage in my painting. For more "vibration" and "push and pull," I often add more "magic" as the painting progresses. Some are, in the end, left light in value; other magical shapes are painted closer in value to the larger areas that surround them.

It's like looking into a kaleidoscope! I never know what new, exciting magical shapes I'll see to visually weave into my painting.

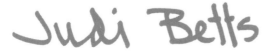

Form, Flow and Color

Chrysalis
22" x 30"
Barbara Nechis

Linkage between idea and technique has always been a factor in my intuitive approach to painting, but my earlier work was more subject-oriented, and soft-edged shapes dominated. My breakthrough came when I noticed the mood created in the paintings in which subject matter was secondary to form, flow and color. I now force the subject to the back of consciousness and focus on the idea. I invent shapes by letting the brushstroke show the possibility of a subject without the limits imposed by the real object.

I introduce new technical elements as well, to force myself to discover new solutions and avoid the repetition found in work that ceases to grow. Rather than forsake the soft edges that dominated my earlier work, I added a linear quality to some by using water-soluble crayon. In others, I broadened the range of color combinations by adding white gouache to my palette. My camera also led me to a discovery: when some years ago I photographed some trees, I noticed from the projected slide their fluid movement. Similar shapes drawn with a brush loaded with water and infused with paint, and with the paper tipped back and forth, produced a result that resembled my slide. The consequent linkage of form and spilling of movement from shape to shape excites me, so now many paintings begin this way.

Although the initial revelation crystallized my breakthrough, I discovered that unconsciously I had used these methods in earlier works. Becoming aware has produced more clarity in my latest work.

Barbara Nechis

Still Life I
38" x 40"
Dee Knott

As My Life Changed, So Did My Painting

For years, a personal challenge had engulfed my life. During this period of time my painting reflected the use of a very limited palette of grays, siennas, blues, etc. It was only after some special people came into my life that my work was enhanced dramatically by a breakthrough; and what a breakthrough it was! As my life changed so did my painting. My palette became alive with a whole range of pigments. My brush took a great surprised delight in dipping into cadmium yellow, rose madder, sap green, etc. It was a difficult transition for many months, but I kept enduring the losses that I experienced. The trash container received a lot of use during this period.

One day *Still Life I* was completed and I was ecstatic. It was created with colors, strokes and washes I'd never used before—I hadn't even known they existed. It was the constant pursuit of the image I had in my mind that led me down this new path. There were no directions or guidebooks. It all comes from the excitement and passion of painting your response to the subject—to push yourself where you've never gone before.

Using what I had learned in *Still Life I*, I concentrated on depicting the sea turtle in all its splendor using the same strong, bold brushstrokes to show the strength of this incredible species. Learning to use value studies has also been crucial in all my paintings. Sometimes wanting to get to the heart of the painting quickly—instead of building a foundation of values first—is a problem I have. I paint what I know and record what I feel and this causes impatience sometimes. But I've learned that values are crucial to my success in these recent works.

Sea Turtle
33" x 40"
Dee Knott

Still Life #1
17" x 23"
Sharon Maczko

Bedroom Floor
18 ¹/₂" x 15 ¹/₂"
Sharon Maczko

Story-Telling Paintings

For several years while working in watercolors, I painted landscapes from personal photographs. I felt very limited by my meager capabilities as a photographer, and I was producing flat, boring paintings. I had always admired the still lifes of the Old Masters, with their feathery, transparent flower petals, dew-laden veggies and bowls of fruit. I decided to set up a still life in my studio in a similar fashion, using vegetables and various items from around my house. The resulting painting, *Still Life #1*, 1985, was by no means a masterpiece, but while setting it up and painting it, I became very aware of the limitless opportunities of painting from life—controlling the lighting and composition, and especially achieving the three-dimensional quality apparent in the newer pieces. All this had been left entirely up to chance by the camera's shutter.

I proceeded to paint more still lifes, although I did and still do push the boundaries of what is generally known as a "still life"; mine became very complicated to construct. It was at this point that I had the confidence I previously lacked in my work to display it publicly.

I feel I reached another breakthrough with *Bedroom Floor*, 1985. I realized I could get the viewer really involved in the painting just as one could become wrapped up in a good book or enthralled with a classic old movie: by having a drama unfold in each painting rather than simply splashing together another meaningless "pretty picture." I also accomplish this story-telling effect by painting in series. I feel one painting cannot always tell the story I want to tell or the feelings I wish to convey; hence my first series, "Bedroom," and the other series I've completed since then.

Sharon Maczko

The Apartment, 30" x 23", Sharon Maczko

Lily Pond
30" x 40"
Virginia Pochmann

Artist's Block Led to Realization

It may be amusing to note that something one of the editors said during an interview for *Splash 1* has led indirectly to another breakthrough in my work... or at least something of a philosophical change.

When we spoke two years ago about my change from large single flowers as subject matter to "microenvironments" as subjects, the editor asked me if I was trying to influence viewers to a point of view regarding the preservation of the environment... or words to that effect. I immediately disclaimed that aim, saying that I am not a political person and did not think art can change people's attitudes about such things. However, for some reason that conversation stuck with me, and other things have convened in my work that brought it back to mind recently. Now I realize that my mind has changed to quite the opposite of what it was back then.

About a year ago, I ran into one of those dreaded "artist's blocks" and quit painting altogether for some months. Gradually I realized that I was up to my gums in flower-and-plant paintings... and all I really wanted to do was habitats wherein small animals live. (I'd always wanted to paint animals, but couldn't find an approach that didn't make them look cutesy or trite, so I hadn't done many of them.) As the ideas germinated I decided the animal would not be large or prominent in the painting, but a focusing point. The point (or content) of the painting would be a subtle statement about ecology and the implied need to preserve natural habitats for small creatures.

So, now I'm out hunting for such places, with my telephoto lens—trying to record such places as holes in stone walls where lizards might hide, or dark caves under jutting rocks, or leaf litter beneath ferns where tiny snakes might be found. With luck and a whole lot of patience, I hope to also find and photograph enough animals to be able to put them into my paintings where I need them.

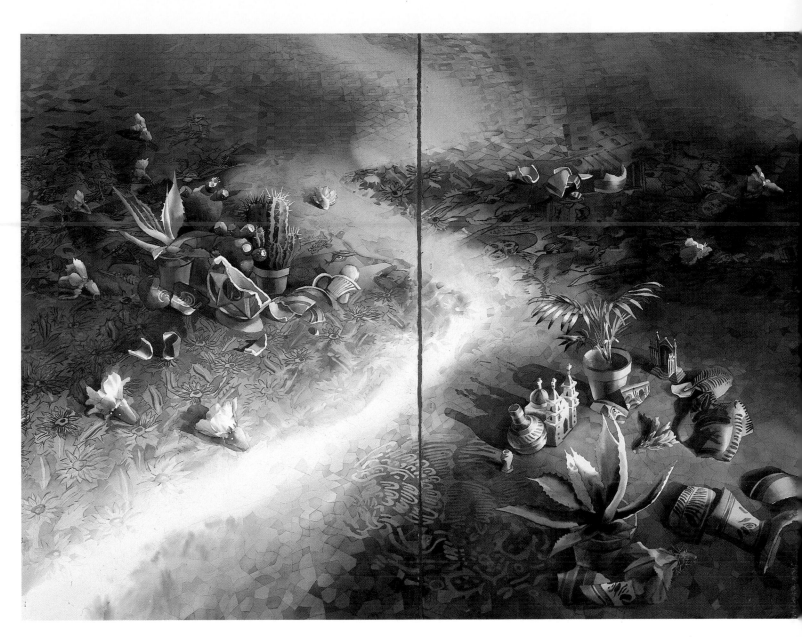

Rio Grande
60" x 82"
Warren Taylor

Expanding Ideas by Scaling Up

Several years ago on a trip back from New York, I visited an old colleague who lives in Missouri. His studio was in the upper level of an old downtown building. As a contemporary oil painter his works were huge. I remember the one in progress measuring 6 feet x 16 feet. As I drove back to Texas, I kept remembering with envy the scale of his work, wishing I could have a bash at a similar size. Several months passed and I began to seriously consider scale. Could my images be expanded?

I reflected on successful ideas such as the work titled *Ojinaga* (in *Splash 1*) and realized that a curious relationship existed between the border cities of Ojinaga, Mexico, and Presidio, Texas. I imagined two large 40" x 60" sheets floating side by side, unified by a meandering white entity which could symbolize the Rio Grande. It worked ... and as a result has expanded my possibilities in planning watercolor and drawing projects. The sections in these works can stand alone, but they work most effectively in tandem. Both Presidio and Ojinaga are typical border cities—disrepair and poverty prevail. In reflecting on how this might be represented in the work, it suddenly came to me that the broken vessel (a symbol ages old) could say it—a broken Mexican *garrafa* (carafe) on one side and a broken American Legion commemorative liquor decanter on the American side. So, whereas the earlier work titled *Ojinaga* romanticized Mexico in rich, shifting chromas, *Rio Grande* at least attempts an honest response to more harsh realities.

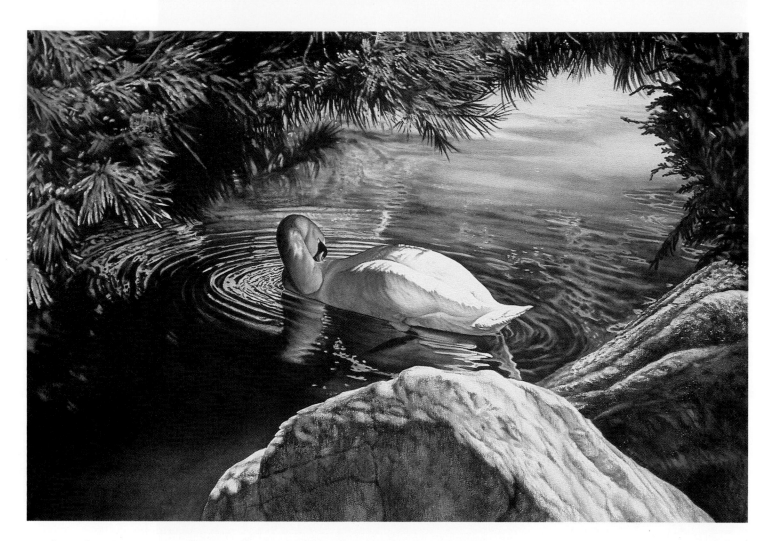

Feather Light #8
29 ¹/₂" x 42"
Linda L. Stevens

Untitled
Linda L. Stevens
(at age 7)

Influence of Early Memories

I believe that an artist's life is a continuous series of breakthroughs—learning to competently use various media, moving from plateau to plateau in terms of technique and also in understanding of the content of the work.

The breakthroughs that have been most important in my painting have been those that deal with content—or the meaning of the work apart from the subject matter represented. In my work, these breakthroughs have resulted in a steady growth and progress toward expression, rather than a dramatic, immediate change. The change can be seen over a span of years rather than from painting to painting.

Several years ago I read a book by Eleanor Munroe, *Originals: American Women Artists*. In the book, Munroe states that she feels there is a correspondence between early memories and an artist's work. She says, "It became progressively more remarkable to me to find almost every conversation I had with these artists sooner or later bearing out Albert Camus's insight: 'The work is nothing else than the long journeying through the labyrinth of art to find again the two or three simple and great images upon which the heart first opened.'"

Munroe's book spoke powerfully to me because I had become increasingly aware that past experiences and memories had made me the kind of artist that I was. I have memories that go much further back than do most individuals—to early days of infancy. Most of these memories revolve around light: light coming through a window, bathing me in a warm glow; light shining through lace curtains or on a wall; light shining on fall leaves, etc.

My paintings are preoccupied with the representation of light. As you can see, this was true even in my childhood work. I also have had an increasing awareness of the spiritual content of the paintings.

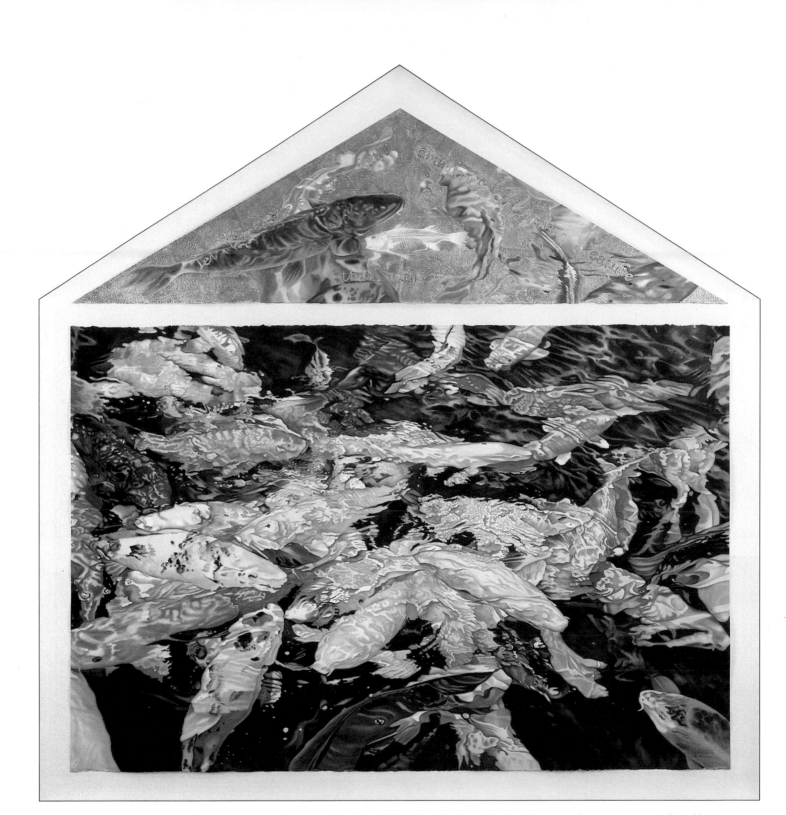

My most recent work incorporates the use of 23K gold leaf, palladium leaf and some aluminum leaf with transparent watercolor. The intent is to create contemporary icons that affirm the sacredness of life. In some paintings of this series ("The Creation" series), I include small portions of the real world (e.g., in *The Fifth Day*, a fish skeleton is mounted in the top portion of the painting). These small samples of the world are intended to represent "relics," or revered objects, as are seen in various religious settings all over the world. The pieces are also intended to suggest ecological overtones.

The Fifth Day
67" x 66"
Linda L. Stevens

9
Change in Attitude

I have experienced several real breakthroughs during my career. These discoveries were marked by substantial conceptual, visual and technical growth. On each occasion, subject, idea and painting approach were strongly rooted to a particular psychological and emotional adventure.

—Elizabeth A. Yarosz

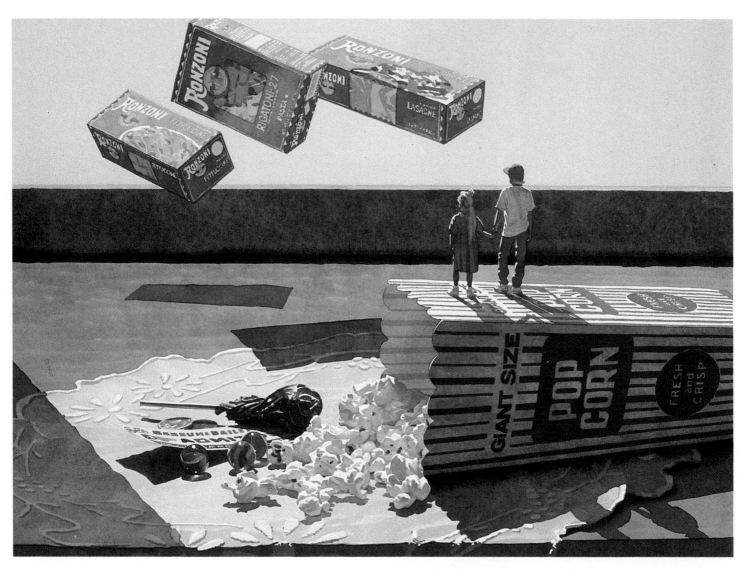

The Fabulous Flying Ronzonis, 32" x 43", Scott Moore

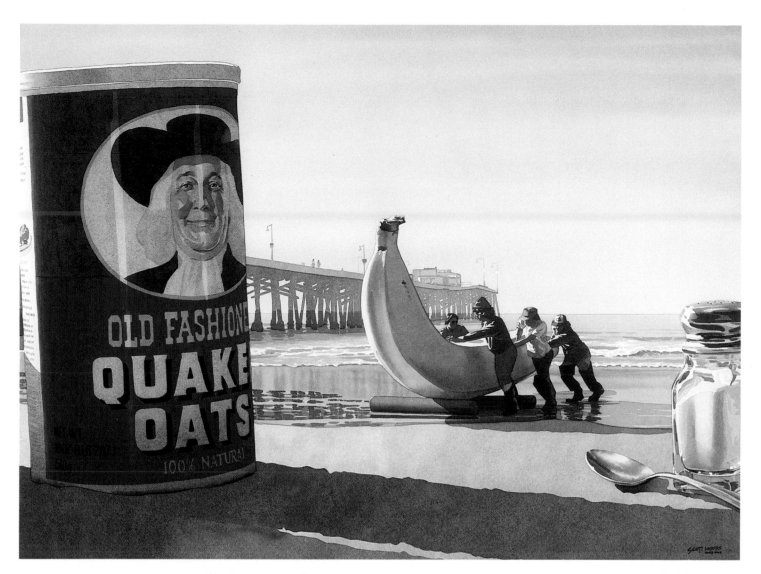

Catch of the Day
30 ¹/₂" x 40 ¹/₂"
Scott Moore

Having Fun While Working

I had always felt that as an artist I had the duty to record the images that I had seen, so that those who came after me would be able to see things the way they were, through my eyes. Although I haven't completely abandoned the idea of being historical within the context of a painting, the need to put on paper and canvas the images that come primarily from my mind, rather than from my eyes, is growing stronger. As I look at my past works, I remember being tempted to alter the images I was looking at. I wanted to put giant fruit in the middle of a street scene or take the central figure of the painting, shrink him and float him over a bowl of soup. It sounded like fun—but art wasn't supposed to be fun, was it? I've found out that painting images that evolve from my mind, whether humorous or serious, are fun. This newfound attitude of having fun while working hard has brought out a new life in my work, giving tomorrow's viewer not only a look at things of my time, but a deeper look into things of my mind.

The Fabulous Flying Ronzonis was based on the Italian flying troupes that entertain at the circus. The objects are things a child might have in a pocket while under the big top.

I used to paint the fishermen in *Catch of the Day* hauling in their boats at Newport Beach, California. I thought they would look good bringing in their catch for breakfast.

Scott m. Moore

Working to Satisfy Myself Only

In 1987 I felt that I had not tried hard enough. Juried shows were no longer teaching me anything. If my work got in a good show, even if it received an award, it could have been because I was relying on a proven way to work that I had developed earlier and already had some good results from. But to take some chances and risk an expanded approach to painting meant working on shaky ground, possibly not having solid enough paintings to enter in a show, let alone get awards. But in the long run, I felt that the year I took the risk—without juried shows and awards to show for it—that year might be much more important to me than the years I stayed safe and won awards. This realization freed me somehow, and I no longer enter shows to compete. I am not saying that this is the case for everyone, it is just the situation for me right now. From that day on I worked more or less to satisfy myself only. (Strange thing for a regular art juror to say, I know.)

My work since then has taken one or two small steps; the beginnings of breakthroughs. My work is not really there yet, but it is more satisfying to me than two to three years ago.

Technically I am working a little differently, too. Somehow I no longer trust accidents; I like all my marks on paper or canvas to be applied and

Day Into Night
39" x 26"
Katherine Chang
Liu

intentional. Therefore, my work may appear more gestural and primal in approach. *Day Into Night* is a painting I did from noon to early the next morning, thus the title.

Just Peaches
19" x 25"
Frances Miller

Learning to Brainstorm

The number one block to creativity is fear. Many artists are hesitant about trying new directions because of the fear of failure. I have managed to overcome this by using brainstorming, learned in a psychology of creativity class I took.

The procedure is:

1. Preparation period—during which you identify a problem to be solved.
2. Period of concentrated effort—when you imagine answers, even obvious and absurd answers, playfully and freely.
3. Period of incubation—during which you withdraw from the problem.
4. Moment of insight.
5. Period of verification, evaluation and application.

I have always searched for different approaches to take, but after trying brainstorming, there was no doubt in my mind how well it works.

The textural quality of peaches was my main goal in *Just Peaches*. I was really pleased to be able to capture their fuzzy essence.

This process of working gives you the courage to risk (to trust your inner intuition) and teaches you the benefit of perseverance. This approach can successfully be used for any quandary in art or life.

Frances Miller

*The Kingsley
Plantation
22" x 30"
Judi Wagner*

Go Beyond What the Eye Sees

My major breakthrough happened when I realized I could go beyond what the eye sees to what the mind and creativity can imagine—and beyond that, to let "the process" open up new watercolor vistas; all this in a semi-realistic setting, using good design, placement and sound picture-making principles.

It is essential for my mind to stay in this exciting "process" of interpretation… and out of the results. What an exciting challenge to take the simple subject matter and see elements that breathe fire into it. Aiming for this goal is most aesthetically rewarding.

I ask myself, How exciting can I interpret this subject matter? Where can I exercise my most creative large patterns of color transitions? Can I stick with the idea that excited me in the first place?

In *The Kingsley Plantation* how better to describe the largeness and whiteness of a building in the southern sun than by leaving 70 percent of the paper untouched? An originality of speech develops when I paint big shapes in a well-designed spot on the picture plane and push the realistic subject beyond itself with the exaggeration of shapes or sizes or color.

Judi Wagner

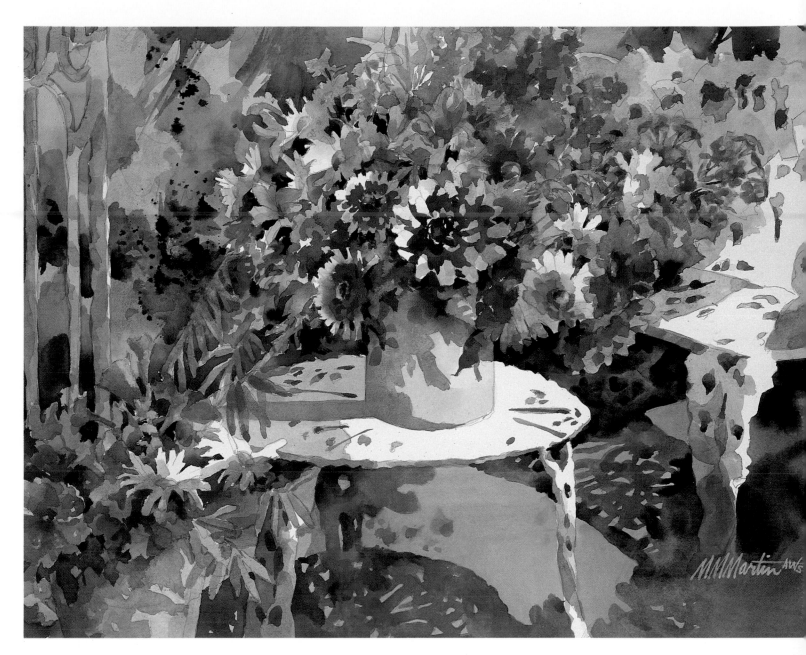

The Connection Between Life and Art

Breakthroughs have been gradual, logical and progressive plateaus for me. They have occurred from internal as well as external forces.

A major breakthrough occurred when I learned and understood that one's life and art are strongly connected and they energize each other. I began to focus and paint my own world. I learned to reach deep within myself and to trust my reactions and make my own decisions. I realized that the quality and consistency of my art improved with focus, preparation, knowledge and trust in what I believed and loved. Truth in one's art is truth in one's self.

Another breakthrough was realizing that truly transparent watercolor painting was for me. I'm really not much for "tricks" in painting or life. I prefer to rely on the direct, immediate sparkle of the medium. The craft is not easy to learn, but I persevered with discipline, intensity, commitment and love. It takes time, and I'm still learning!

Margaret M. Martin

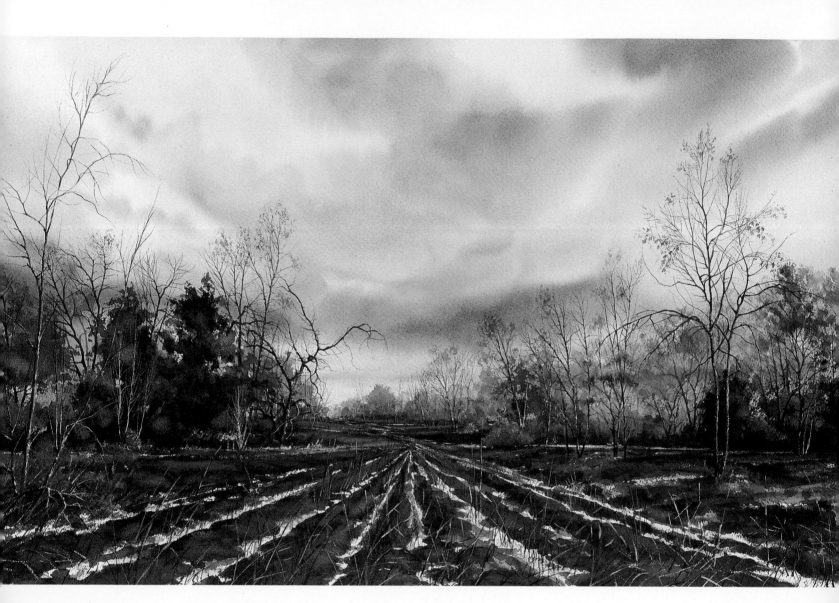

Another Season
12" x 19"
David M. Band

Reaching New Plateaus

When considering breakthroughs in my work, I place the emphasis on the emotional aspects rather than the technical. I look upon watercolor as a language, and in any language it is vital that the fundamentals are stressed, applied and practiced to ensure proficiency.

Developing these skills instills confidence, and with this a state of mind that I refer to as the "comfort zone." This can be a style, formula or subject that one is identified with that works and ensures approval. Remaining in the comfort zone is easy, but this does not guarantee growth or success.

I have found my most significant breakthroughs and periods of development to be closely associated with, or the result of, great pleasure or unforeseen sadness. It is at these times that sensitivity, awareness and vulnerability bring the walls of my comfort zone crumbling down, enabling me to reach new plateaus of development and, with this, a new comfort zone.

David M. Band

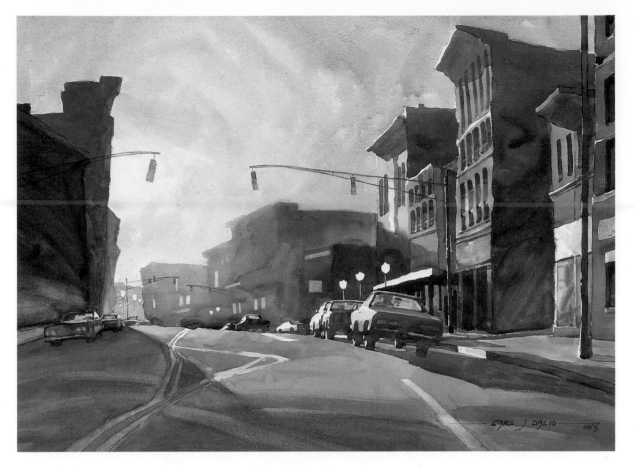

Afternoon Glare—
Main Street
21" x 29"
Carl J. Dalio

Thinking, Living and Breathing Art

In earlier attempts to communicate my observations, I recorded visual information in a fairly accurate manner. I hoped to view the perfect subject bathed in the perfect light arranged in the perfect composition, in fact, the perfect… masterpiece! I felt it possibly existed and I would find it if I just searched long enough.

Through time and experience, a profound change has taken place inside me. Through incremental movements, I have become more interested in interpreting subject matter in more creative ways than the "locked in" reality of the existing world. I have become more interested in the "process" of painting—more interested in thinking, living and breathing art. Through this journey, I am affirmed in my life as an artist and teacher; I have become a "whole" person fully cognizant of the wonderful privilege of being able to create art.

The painting *Afternoon Glare—Main Street* is a revelation of my initial explorations in this exciting arena. As I drove through the main street of Trinidad, Colorado, one late afternoon, I came across this amazing display of glaring sunlight. Circling the town, I came back across this same location several minutes later only to find the sun had disappeared below the horizon. Taking a fast, disappointing photo, I returned to Denver days later and painted a quick, small watercolor from memory and photo reference.

Developing a larger watercolor, I began to manipulate the reality of street and building forms, dropping nonessential detail, arching the road, leaning the marching buildings, placing spiraling brushstrokes in a dusty sky, emphasizing movement and atmosphere. The result is a painting that communicates that powerful slice out of time as light and wind flow as one down the quiet streets of Trinidad.

— CARL J DALIO — AWS

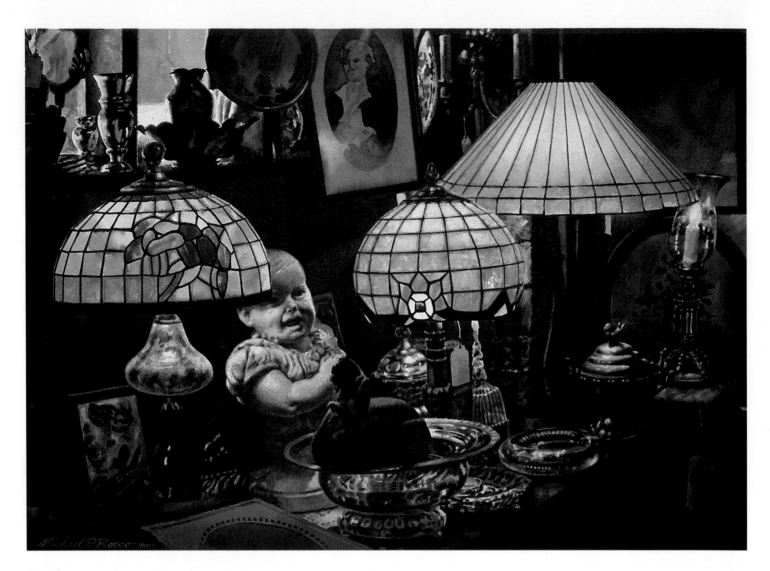

Nostalgia
18" x 24"
Michael P. Rocco

Perseverance

My breakthrough was, and still is, perseverance! In my student days at art school I painted my watercolors on location in all types of weather, completing as much as possible and, if necessary, finishing the paintings at home. I never gave up on a painting. Even though I may not have been satisfied with the result, there was always something I gained from it: Painting outdoors, observing how light affects shadows, painting quickly due to light changes, attempting the unusual. This was my learning experience—my breakthrough that I feel has rewarded me in my present work.

I am not a painter that experiments. I just use straightforward, transparent watercolor but with a real conviction to strong composition—strength of color, texture and emotion. Confidence comes from experience; experience comes through perseverance.

Michael P. Rocco AWS

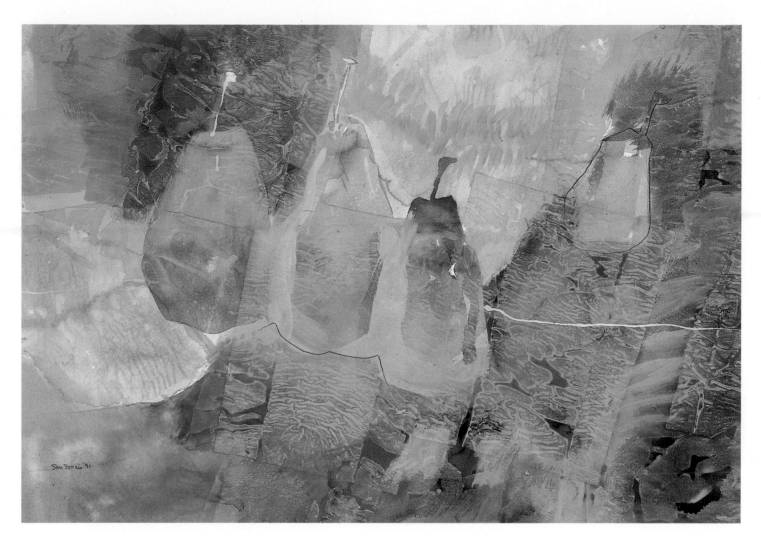

Artist: It's My Job

Les Poires
22" x 30"
Pat San Soucie

It took awhile.

The breakthrough that helped me most significantly came several years ago when I took a spyglass look at myself, my work and my life. I decided that:

I was in control; my work was generally good; I was setting a pace and direction, finding a niche; and I was saying things I wanted to say.

None of this was a startling revelation to be shouted from treetops; it was Inner Self having a talk with Self. It was the student beginning to grow up, the eager one who always stared worshipfully at the work of "real artists" and teachers. The student is still here, looking, reading and wondering, but learning to be pleased enough with her own inventions, poetry and sensitivities.

It is the difference in my attitude lately that seems to count most. It is me, the person inside, who constitutes my own art world. All that I have been taught, have done or won are welcome points on the achievement curve. Many much-needed insights happen along the way toward recognizing which of my efforts seemed the best, toward the secret glee of "daring to be different," and toward playing and never growing up while celebrating with paint.

But I no longer have to linger in the hopeful waiting lines, wondering where is the right place to stand so someone someday will confer a unique title on me. I did it myself: *artist*. It's my job. I took on that label with all I think it means, and I will continue to explore with paint, color, paper, accidents and ideas, adding my own quirks and whimsies, to make my art. Other people's work will always astound me, but I can't do theirs; I have to do mine, feeling kinship with the cave painters and all since. It is a good job.

San Soucie

Memories of the Past
22" x 30"
Carole D. Barnes

A Deeper Response

Living in Colorado has been a major influence in my work. I love our mountains and my intent has been to show their strength, their grandeur, and to do it with the color and texture that I love. Although I am painting nature, I am thinking and feeling the spirit of nature—the essence of it and my love for it. My breakthrough has been a deeper response to my subjects.

Carole Barnes

A Dialogue Between Artist and Paper

The Ore Wagon
15" x 22"
Tony van Hasselt

Due to a very academic background, my first attempts at landscape painting in watercolor were very frustrating. I tried to exactly copy the landscape in front of me. The values, colors and shapes all had to be precisely as I saw them. It was a one-way conversation; it was me desperately forcing my will onto the paper. I was unaware that a watercolor can and should be a wonderful dialogue between the artist and the paper.

Apparently, this is a normal phase. I see beginning students having those same problems. When we become aware that the paper can be our friend, things get better. If I am willing to look and "listen," the paper will try to help me create a more exciting watercolor. This means that I have to be more aware of what is *on* the paper rather than what I have *in mind* to be on the paper. This means that I'm very reluctant to automatically cover up some precious white spots just because there is nothing like that in the subject. Instead, I question, Could I turn these whites into birds or people or laundry on a line? Would these whites enliven this area or confuse matters? I am also very aware of the shapes that develop on the paper while I am painting. Besides what I had in mind, what else can these shapes suggest? My end result may look representational, but hopefully it is much more exciting than the actual scene.

Volcanic Eruption on Seous
36" x 29"
Edward Minchin

Milkweed Movement
(above right)
29" x 36"
Edward Minchin

Nurture the Inner Self

The old saying "Hitch your wagon to a star" often implies a sure road to success. This idea also suggests following someone else's trail or walking in their footsteps. My initial breakthrough came when I realized I had to become the star, shining and illuminated in my own right, the source of which comes from within, not from someone else's inspiration. Developing, nurturing and relying on my inner self has resulted in unlimited expression and a positive direction.

I had three important painting breakthroughs:

1. The discovery of a wonderful world of strong design and composition in close-ups or the focusing in on a specific idea, as in *Milkweed Movement*. With my own loose semi-abstract style, I help the viewer see ordinary things in a different way.
2. Through experimentation and by allowing the painting to lead, I was able to transcend the landscape art into what I call celestial expressions. This idea has launched me into a world of incredible color and imagination (see *Volcanic Eruption on Seous*).
3. Perhaps the last frontier to explore is the inner self, which promises totally new phenomena of color and perhaps a new language of shape and expression in painting for the future.

Edward Minchin AWS.

Preserving the Things We Want to Paint

The Rock Garden
19" x 25"
Mary Ann Chater

When I first started painting, I was in love with the medium, all the rich glowing colors, the texture and whiteness of the paper. I would paint anything—flowers, trees, birds, animals, waterfalls, people, clouds, anything.

Now I'm still in love with the medium but also aware of the importance of preserving the very things we want to paint.

My current body of work deals with the relationships between man and nature and the relative importance of these positions. Since I feel that man is no more or less important than the pebbles on a beach, fish in the sea or flowers in a field, I paint him on a scale with his surroundings. Because I take my subject, but not myself, seriously, my paintings have a sense of fun that prompts pleased recognition from the viewer.

While being open to new techniques and supplies, and constantly being stimulated by other artists' work, my breakthrough occurred when I began painting beliefs rather than "anything."

No More Tomorrows
18 ¹/₄" x 27 ¹/₄"
Donald W.
Patterson

One Goal—Be Myself

I received my first formal watercolor training in 1947. My breakthrough came forty-five years later! Not exactly an overnight success. Please understand, I was not slaving away on watercolors for all this time. Quite the contrary. Supporting myself and my family took precedence over everything else. For thirty years I worked as a graphic arts designer and illustrator. During the course of all this, I "played" with watercolor. Of course working commercially, I was always obliged to "follow orders" and make sure the client or boss was kept happy.

Gradually it occurred to me that just being myself and pleasing myself as an artist was becoming more and more vital to my personal happiness. After my three sons were grown and educated, I decided it was time for *me*. I started painting on a regular schedule with only one goal in mind—be myself! I never worry about the critics or how other artists work. I only paint what really interests and excites me, and develop my own solutions and methods to accomplish my desired results. This was my breakthrough.

One of my breakthrough techniques is the use of Winsor & Newton masking fluid. In *No More Tomorrows*, the grasses, trees and reeds were developed by drawing them first with the masking fluid, painting the negative areas with color and removing the masking fluid, and staining the positive areas with color. The important thing, however, is that the style I use in painting a watercolor is my own, built on a solid education, many years of personal observation and practice. This way I am always in natural control of my work and my work is always me. What more could I ask?

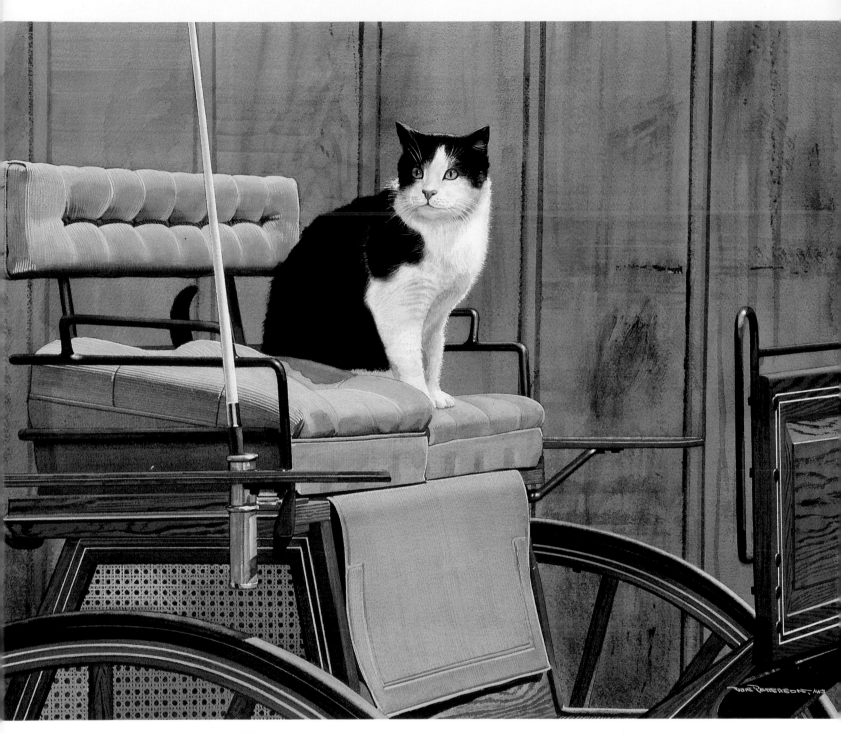

Your Carriage Awaits, 20" x 25", Donald W. Patterson

Neil H. Adamson, NWS, 7089 S. Shore Drive, S. Pasadena Island, FL 33707
p. 82 (*top*)—*Salt Water Asters* ©Neil H. Adamson, collection of the artist,
p. 82 (*bottom*)—*River Mist* ©Neil H. Adamson, collection of the artist

Gary Akers, AWS, P.O. Box 200, Spruce Head, ME 04859; P.O. Box 100, Union, KY 41091
p. 83—*Winter's Grays* ©Gary Akers, collection of Jo Ann Seltman

John Atwater, AWS, Avon, CT
p. 2—*Bait Gloves* ©1987 John Atwater, collection of Richard and Maureen Boyle
p. 32—*Christmas Cove* ©John Atwater, collection of Lois and Austin Drukker
p. 33—*Leaving Monhegan* ©John Atwater, collection of Phyllis and Jonathan Miller

David M. Band, 1903 Eden Lane, Wichita Falls, TX 76306
p. 120—*Another Season* ©David M. Band, collection of Mike and Pat Craddock, Midland, TX

Carole D. Barnes, AWS, 3772 Lakebriar Drive, Boulder, CO 80304
p. 124—*Memories of the Past* ©Carole D. Barnes, collection of the artist

Mary Ann Beckwith, 619 Lake, Hancock, MI 49930
p. 90—*Origins: The Beginning* ©1990 Mary Ann Beckwith, collection of the artist

Judi Betts, AWS, P.O. Box 3676, Baton Rouge, LA 70821-3676
p. 102—*Patio Party* ©1990 Judi Betts, collection of Don and Wanda Tonnemacher, Whittier, CA

Joseph Bohler, AWS, P.O. Box 387, Monument, CO 80132
p. 30—*Tribute* ©1990 Joseph Bohler, collection of the artist

Charlotte Britton, AWS, 2300 Alva Avenue, El Cerrito, CA 94530
p. 58—*Garden Path* ©1991 Charlotte Britton, collection of Gerry and Barbara Lane

Al Brouillette, AWS, 1300 Sunset Court, Arlington, TX 76013
p. 88—*Kaleidoscope* ©Al Brouillette
p. 89—*Bird of Paradise Trio* ©Al Brouillette

Marbury Hill Brown, AWS, NWS, P.O. Box 574, Nederland, CO 80466
p. 39—*Flea Market* ©Marbury Hill Brown, collection of the artist

Ranulph Bye, ANA, AWS, P.O. Box 362, Mechanicsville, PA 18934
p. 22—*The Walkway* ©1987 Ranulph Bye, collection of Ms. Linda Langham, Philadelphia, PA
p. 23—*Foundations* ©1989 Ranulph Bye, collection of Mr. and Mrs. Harry Rose, Newtown, PA

Louise Cadillac, 880 South Dudley St., Lakewood, CO 80226
p. 42 (*left*)—*Implosion* ©1991 Louise Cadillac, courtesy Alpha Gallery, Denver, CO
p. 42 (*right*)—*Yellow Line* ©1991 Louise Cadillac, courtesy Alpha Gallery, Denver, CO

Mary Ann Chater, Westlake Village, CA
p. 127—*The Rock Garden* ©1990 Mary Ann Chater, collection of the artist

Roberta Carter Clark, 47-B Cheshire Square, Little Silver, NJ 07739
p. 94—*Daffodils With Blue* ©1990 Roberta Carter Clark

Robert W. Daley, AWS, 11 Manor House Ct., Holyoke, MA 01240

pp. 66-67—*The Path From Here to There* ©1991 Robert Daley, collection of the artist

Carl J. Dalio, AWS, NWS, 2224 South Downing, Denver, CO 80210
p. 45—*Family Picnic* ©1988 Carl J. Dalio, collection of Mr. and Mrs. Fred S. Kummer Jr.
p. 121—*Afternoon Glare—Main Street* ©1991 Carl J. Dalio, collection of the artist

Stephen De Santo, 1325 Kensington Blvd., Fort Wayne, IN 46805
p. 100—*Special Places* ©Stephen De Santo

Pat Deadman, AWS, NWS, 105 Townhouse Lane, Corpus Christi, TX 78412
p. 70 (top)—*Santa Elena* ©Pat Deadman
p. 70 (bottom)—*Santa Elena* photograph ©Pat Deadman

George W. Delaney, AWS, 17 Champlain Ave., Staten Island, NY 10306
p. 50—*Ed Whitney* ©George W. Delaney
p. 51—*Joe* ©George W. Delaney

Pat Dews, NWS, P.O. Box 593, Matawan, NJ 07747
p. 79—*Spindrift II* ©Pat Dews
p. 97—*Water's Edge* ©Pat Dews

Jeanne Dobie, AWS, NWS, Hidden Valley Studio, 160 Hunt Valley Circle, Berwyn, PA 19312
p. 29—*Pigeon's Roost* ©1990 Jeanne Dobie, collection of the artist
p. 28—*VIP Cottage* ©1990 Jeanne Dobie, collection of the artist

J. Everett Draper, AWS, P.O. Box 12, Ponte Vedra Beach, FL 32004
p. 78—*Sloppy Joe's, Key West* ©1990 J. Everett Draper, private collection

Neil Drevitson, AWS, PSA, Church Hill Road Box 515, Woodstock, VT 05091
p. 8—*The Cement Mixer* ©1990 Neil Drevitson, collection of Mr. and Mrs. Sidney Schwartz

Renée Faure, AWS, 600 Second Street, Neptune Beach, FL 32266
p. 74—*Le Jardin aux Nénuphars* ©1989 Renée Faure, collection of Mr. Jack Diamond
p. 75—*Les Roses de la Méditerranée* ©1989 Renée Faure, collection of Dr. Edward Ossi

Mary Lou Ferbert, AWS, 334 Parklawn Drive, Cleveland, OH 44116
p. 110—*Grapevine and Old Warehouse* ©Mary Lou Ferbert
p. 111—*Chicory and Flatiron Building* ©Mary Lou Ferbert

Jorge Bowen Forbes, AWS, P.O. Box 1821, Oakland, CA 94612
p. 93—*Vreedenhoop* ©1986 Jorge Bowen Forbes, collection of National Collection, GUYANA

John Gaddis, AWS, 111 River Place, Jackson, MS 39211
p. 52—*South of Suez* ©John Gaddis, collection of Mr. and Mrs. W.F. Goodman, Jr., Jackson, MS

Irwin Greenberg, AWS, 17 W. 67 St., New York, NY 10023
p. 16—*Grand Central Station* ©1991 Irwin Greenberg
p. 17—*Times Square Nocturne* ©1991 Irwin Greenberg

Alexander J. Guthrie, AWS-DF, 7928 Shoup Avenue, Canoga Park, CA 91304
p. 71—*Arrested Obsolescence* ©1990 Alexander J. Guthrie, courtesy of the Louis Newman Galleries, Beverly Hills, CA

Robert Hallett, NWS, 1374 Calle Galante, San Dimas, CA 91773
p. 38 (*top left*)—*High and Dry* ©1990 Robert Hallett
p. 38 (*bottom left*)—*Crystal Cove* ©1990 Robert Hallett

p. 38 (right)—*Refitting* ©1990 Robert Hallett

Elaine L. Harvey, 1602 Sunhurst Drive, El Cajon, CA 92021

 p. 44—*Upwardly Mobile Weeds* ©Elaine L. Harvey

Randall R. Higdon, AWS, 7203 Willobee St., Coloma, MI 49038

 p. 6—*Reaching for Sunlight* ©1990 Randall Higdon, collection of
 Monroe County Community College, Monroe, MI

Tom Hill, AWS, Tucson, AZ

 p. 43—*Piazza San Marco* ©Tom Hill, private collection

Jane R. Hofstetter, NWS, 308 Dawson Drive, Santa Clara, CA 95051

 p. 59—*Hollyhocks* ©1991 Jane R. Hofstetter, collection of the artist

Donald Holden, 128 Deertrack Lane, Irvington, NY 10533

 p. 62—*Forest Fire II* ©1989 Donald Holden, collection, Captain
 Nelson P. Jackson, photo courtesy Susan Conway Gallery,
 Washington, DC

 p. 63—*Yellowstone Fire XI* ©1989 Donald Holden, collection,
 Gerhard Dreo, photo courtesy Susan Conway Gallery, Washington,
 DC

Serge Hollerbach, AWS, 304 West 75 St., New York, NY 10023

 p. 7—*After the Snowfall* ©Serge Hollerbach, collection of Mr. and
 Mrs. Paul Hondros

Bill James, AWS, PSA, 15840 S.W. 79th Ct., Miami, FL 33157

 p. 54—*Bald Man* ©1984 Bill James

 p. 55—*Turk's Cap* ©1990 Bill James

Robert Johansen

 p. 37 (top)—*Sand Bay* ©Robert Johansen, collection of Mrs. Kathleen
 R. Johansen

 p. 37 (bottom)—Drawing from *Sand Bay* ©Robert Johansen

Kwan Y. Jung, AWS, 5468 Bloch Street, San Diego, CA 92122

 p. 72—*Snow Rider* ©Kwan Y. Jung, collection of the artist

Arthur L. Kaye, 5441 Alcove Ave., N. Hollywood, CA 91607

 p. 9—*Crescendo* ©1991 Arthur L. Kaye, collection of the artist

Dee Knott, AWS, 536 Ashwood Drive, Flushing, MI 48433

 p. 104—*Still Life I* ©1991 Dee Knott, collection of Mr. and Mrs.
 Howard Grossman

 p. 105—*Sea Turtle* ©1991 Dee Knott

Jan Kunz, P.O. Box 868, Newport, OR 97365

 p. 36—*Lilacs and Silver* ©1991 Jan Kunz, collection of the artist

George S. Labadie, AWS, NWS, 22940 Calabash St., Woodland Hills,
CA 91364

 p. 10—*Ten Minutes to Curtain* ©George S. Labadie, collection of Dr.
 and Mrs. Robert Ledner

 p. 11—*Next* ©George S. Labadie, collection of the artist

Katherine Chang Liu, 1338 Heritage Place, Westlake Village, CA
91362

 p. 116—*Day Into Night* ©Katherine Chang Liu, courtesy Louis
 Newman Galleries, Los Angeles

Barbara Luebke-Hill, 4605 Cerro de Aguila, Tucson, AZ 85718

 p. 31—*Shallow Waters* ©Barbara Luebke Hill, collection of Dr. and
 Mrs. Ross Chapin

Sharon Maczko, 936 W. 18th St., #E4, Costa Mesa, CA 92627

 p. 106 (left)—*Still Life #1* ©1985 Sharon Maczko, collection of Ken
 and Kelly Carpenter, Huntington Beach, CA

 p. 106 (right)—*Bedroom Floor* ©1985 Sharon Maczko, collection of
 The Jonathan Club, Los Angeles

 p. 107—*The Apartment* ©1986 Sharon Maczko, collection of The

Jonathan Club, Los Angeles

Daniel J. Marsula, Pittsburgh, PA

 p. 84—*At Rest* ©1990 Daniel J. Marsula, available through James
 Gallery, Pittsburgh, PA

 p. 85—*Lisa* ©1990 Daniel J. Marsula, private collection

Margaret M. Martin, AWS, 69 Elmwood Avenue, Buffalo, NY 14201

 p. 119—*Country Gala* ©1988 Margaret M. Martin

Maxine Masterfield, AWS, 3968 Lakeside Road, Sarasota, FL 34232

 p. 53—*Stillness* ©1991 Maxine Masterfield, collection of the artist

Alex McKibbin, Studio: 3726 Pamajera Drive, Oxford, OH 45056

 p. 69—*Environs of Pamajera #136* ©Alex McKibbin, photography by
 Carl Potteiger

Frances Miller, 2985 W. Sacramento Ave., Chico, CA 95926

 p. 117—*Just Peaches* ©1988 Frances Miller, collection of Mr. and
 Mrs. Ben Barker

Kathleen Conover Miller, 1390 Vandenboom, Marquette, MI 49855

 p. 68—*Frozen Night Pond* ©1991 Kathleen Conover Miller

Edward Minchin, P.O. Box 160, Rockland, MA 02370

 p. 126 (left)—*Volcanic Eruption on Seous* ©1991 Edward Minchin,
 collection of the artist

 p. 126 (right)—*Milkweed Movement* ©1991 Edward Minchin,
 collection of the artist

Scott M. Moore, AWS, 1435 Regatta Road, Laguna Beach, CA 92651

 p. 114—*The Fabulous Flying Ronzonis* ©Scott M. Moore, collection of
 Mr. and Mrs. Sheldon Kwiat, Long Island, NY

 p. 115—*Catch of the Day* ©Scott M. Moore, collection of the Quaker
 Oats Company, Chicago, IL

Barbara Nechis, AWS, 1085 Dunaweal Lane, Calistoga, CA 94515

 p. 103—*Chrysalis* ©1991 Barbara Nechis, collection of the artist

Frank Nofer, 501 Dogwood Lane, Conshohocken, PA 19428

 p. 40—*Italian Market* ©1991 Frank Nofer, collection of the artist

 p. 41 (top)—*Nutmeg and Roses* ©1991 Frank Nofer, collection of
 Mr. and Mrs. William Wise

 p. 41 (bottom)—*Guadeloupe Trio* ©1991 Frank Nofer, private
 collection

Meredith Ann Olson, 315 Wonderview Drive, Glendale, CA 91202

 p. 27—*Wonderview* ©Meredith Ann Olson

Donald W. Patterson, AWS, 529 Longfellow Lane, Media, PA 19063

 p. 128—*No More Tomorrows* ©1989 Donald W. Patterson

 p. 129—*Your Carriage Awaits* ©Donald W. Patterson, collection of
 Art Marketing Group, Inc.

Donald J. Phillips, AWS, 1755 49th Ave., Capitola, CA 95010

 p. 56 (left)—*Hyde Street to the Bay* ©1988 Donald J. Phillips,
 collection of Frank Higgins, Irvine, CA

Carlton Plummer, AWS, 10 Monument Hill Road, Chelmsford, MA
01824

 p. 76—*Port Clyde Sundown* ©Carlton B. Plummer, collection of the
 artist

 p. 77—*Lobsterman's Retreat* ©Carlton B. Plummer, collection of
 the artist

Virginia Pochmann, 235 Oak Road, Danville, CA 94526

 p. 108—*Lily Pond* ©1989 Virginia Pochmann, collection of City of
 Sunnyvale, CA

Alex Powers, 401 72nd Ave., N., Apt. 1, Myrtle Beach, SC 29577

 p. 24 (top)—*Three Soldiers* ©1991 Alex Powers, collection of

the artist

p. 24 (*bottom*)—*Golf II* ©1991 Alex Powers, collection of Elsie and Jim Boyce, Leawood, KS

p. 25—*Civil War Soldiers* ©1991 Alex Powers, collection of the artist

Susan McKinnon Rasmussen, 2225 S.W. Winchester Avenue, Portland, OR 97225

p. 98—*Stars and Stripes* ©1991 Susan McKinnon Rasmussen, courtesy of Maveety Gallery

p. 99—*Spring Fanfare* ©1990 Susan McKinnon Rasmussen, collection of Mr. and Mrs. Leland Larsen

Michael P. Rocco, AWS, 2026 S. Newkirk Street, Philadelphia, PA 19145

p. 122—*Nostalgia* ©Michael P. Rocco

Priscilla Taylor Rosenberger, 325 Portzer Rd., Quakertown, PA 18951

p. 57—*Jars and Romes* ©1981 Priscilla Taylor Rosenberger

Paul St. Denis, AWS, NWS, 28007 Sites Road, Bay Village, OH 44140

p. 34—*Falconer* ©1989 Paul St. Denis, collection of Dr. Ruben G. Plaza

p. 35—*Fish Skull* ©Paul St. Denis

p. 91—*Rainbow Palette* ©1991 Paul St. Denis, collection of the artist

Robert Sakson, AWS, PSA, AAA, 10 Stacey Avenue, Trenton, NJ 08618-3421

p. 20 (*top*)—*The Gathering* ©1989 Robert Sakson, collection of Dr. and Mrs. Albert Carabelli

p. 20 (*bottom*)—*Howell Farm* ©1989 Robert Sakson, collection of the artist

Pat San Soucie, Manalapan, NJ

p. 123—*Les Poires* ©1991 Pat San Soucie, collection of Mr. and Mrs. Howard R. Berlin, Holmdel, NJ

Michael Schlicting, AWS, P.O. Box 794, Neskowin, OR 97149

p. 47—*Easter* ©1987 Michael Schlicting, collection of Mr. and Mrs. J.W. Lewis

Betsy Schneider, 11726 Monte Leon, Northridge, CA 91326

p. 95 (*top*)—*Double Exposure #13* ©Betsy Schneider, collection of the artist

p. 95 (*bottom*)—*Live Oak* ©Betsy Schneider, collection of the artist

Leo Smith, AWS, 3008 Townsend, Dallas, TX 75229

p. 101—*Afternoon* ©Leo Smith, collection of Stephanie Smith

Susanna Spann, 1729 8th Avenue W., Bradenton, FL 34205

p. 96—*Remembrances and Regrets* ©1989 Susanna Spann, collection of Joanna and Paul Hall

Electra Stamelos, 5118 Royal Vale Lane, Dearborn, MI 48126

p. 73—*Composition VII* ©1990 Electra Stamelos, courtesy of Lemberg Gallery, Birmingham, MI

Linda L. Stevens, 9622 Zetland Drive, Huntington Beach, CA 92646

p. 112 (*top*)—*Feather Light #8* ©1988 Linda L. Stevens, collection of Joanne and Marc Bittan, Los Angeles

p. 112 (*bottom*)—Untitled painting ©1949 Linda L. Stevens, collection of the artist

p. 113—*The Fifth Day* ©1990 Linda L. Stevens, courtesy of Louis Newman Galleries, Beverly Hills, CA

Al Stine, 3416 Highway 81 North, Anderson, SC 29621

p. 15—*Mr. Wilson* ©1990 Al Stine, collection of Mr. and Mrs. Denis Coulon, Laconnex, Switzerland

Donald Stoltenberg, AWS, 947 Satucket Road, Brewster, MA 02631

p. 26—*Restoration* ©Donald Stoltenberg

Zoltan Szabo, 1220 Glenn Valley Drive, Matthews, NC 28105

p. 14—*Spring Curtain* ©Zoltan Szabo

Warren Taylor, AWS, P.O. Box 50051, Midland, TX 79710-0051

p. 109—*Rio Grande* ©Warren Taylor, collection of the artist

Nedra Tornay, 2131 Salt Air Drive, Santa Ana, CA 92705

p. 12—*Cabbage* ©1987 Nedra Tornay, collection of the artist

p. 13—*Cactus II* ©1990 Nedra Tornay, collection of Mr. and Mrs. Sheldon Barker

Jane Van Dyke, NWS, 1017 Country Club Drive, N. Palm Beach, FL 33408

p. 80—*Vine Essence I* ©1984 Jane Van Dyke, private collection

p. 81—*Yesterday's Treasures* ©1988 Jane Van Dyke, private collection

Tony van Hasselt, AWS, P.O. Box 1418, Sarasota, FL 34230

p. 125—*The Ore Wagon* ©Tony van Hasselt

William M. Vrscak, AWS, 720 Sylvan Avenue, Pittsburgh, PA 15202

p. 21—*Brookline Morning* ©William M. Vrscak

Judi Wagner, HC 65, Box #834, E. Boothbay, ME 04544

p. 118—*The Kingsley Plantation* ©Judi Wagner

Frank Webb, AWS, 108 Washington St., Pittsburgh, PA 15218

p. 61—*Mont Tremblant* ©1990 Frank Webb, collection of the artist

Michael J. Weber, AWS, 12780 59th St. North, Royal Palm Beach, FL 33411

p. 18—*Tea for Three* ©1990 Michael J. Weber; poster of this painting ©Springdale Graphics, CT

p. 19—*Fresh Eggs* ©1990 Michael J. Weber, private collection

Joyce Williams, AWS, NWS, P.O. Box 2586, Ashland, KY 41105, P.O. Box 192, Tenants Harbor, ME 04860

p. 46—*Seekers of the Shrine* ©1991 Joyce Williams, collection of the artist

p. 92—*Weathered Vane* ©1984 Joyce Williams, collection of the artist

Lynne Yancha, AWS, 360 Lynn Avenue, Landisville, PA 17538

p. 4—*Bridget* ©1989 Lynne Yancha, private collection

p. 5—*Home from School* ©1990 Lynne Yancha, collection of the artist

Elizabeth A. Yarosz, 1707 Victory Avenue, Wichita Falls, TX 76301

p. 64—*Gothic Revival* ©1991 Elizabeth A. Yarosz, collection of the artist

p. 65—*In Search of the Perfect Dwelling* ©1985 Elizabeth A. Yarosz, collection of Mr. and Mrs. Robert C. Kramer, Springfield, MO

Donna Zagotta, 7147 Winding Trail, Brighton, MI 48116

p. 60—*The Solarium* ©1990 Donna Zagotta, collection of the artist